Carolee Schneemann

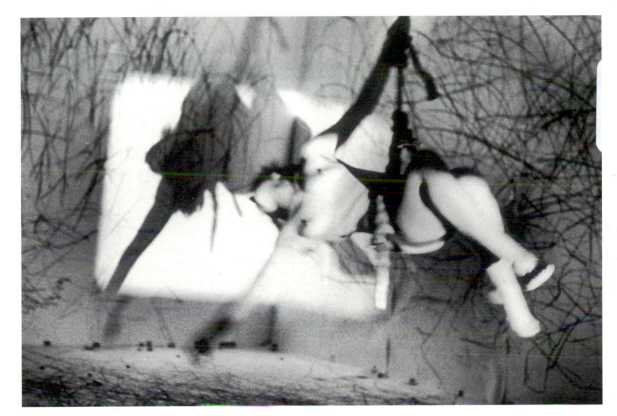

Up To and Including Her Limits

November 24, 1996 – January 26, 1997

The New Museum of Contemporary Art, New York

Carolee Schneeman: Up To And Including Her Limits

Organized by Dan Cameron
The New Museum of Contemporary Art
November 24, 1996 – January 26, 1997

Library of Congress Catalog Card Number: 96-71007
ISBN 0-915557-80-0

The individual views expressed in the exhibition and publication are not necessarily those of The New Museum.

The New Museum of Contemporary Art
583 Broadway
New York, NY 10012

Title page: *Up To And Including Her Limits,* February 13-14, 1976, The Kitchen, New York, performance view. Photo: Shelley Farkas Davis

Back cover: *Up To And Including Her Limits,* June 10, 1976, Studiogalerie, Berlin, performance view. Photo: Henrik Gaard

Exhibition

Curator	Dan Cameron
Exhibition coordinator	Melanie Franklin
Exhibition supervision	John Hatfield
Installation coordinator	Patricia Thornley
Programs coordinator	Raina Lampkins-Fielder
Curatorial interns	Moni Ozgilik, Sefa Saglam
Video editing	Dieter Froese

Catalogue

Production	Melanie Franklin
Designer	Tony Morgan, Step Graphics
Editor	Kathy Brew
Authors	Dan Cameron, David Levi Strauss, Kristine Stiles
Custom photography	Ben Caswell
Printing	Becotte & Gershwin

Table of Contents

Acknowledgements

Because the nature of Carolee Schneemann's work has been to address issues of a more or less transient nature — performance, love, mortality — it has relied on the support and participation over time of scores of individuals who have donated their skills and energy to realizing another's vision. On behalf of the artist, The New Museum of Contemporary Art would like to acknowledge its debt to the many photographers, dancers, filmmakers, composers and other collaborators whose efforts were essential in creating the works on view.

This exhibition could not have taken place without the efforts of passionate individuals and foundations whose dedication to advanced art practices makes it possible for The New Museum to pursue its mission. Special thanks are owed to the David and Penny McCall Foundation, the Norton Family Foundation, and the Andy Warhol Foundation for the Visual Arts for their generous donations to this undertaking. We would also like to thank Alexandra Anderson-Spivy and Eileen and Peter Norton who have graciously lent works to the exhibition.

Although there are many colleagues at The New Museum whose support of this exhibition and programs has been critical to its successful execution, I want to acknowledge especially Susan Cahan, Melanie Franklin, John Hatfield, Raina Lampkins-Fielder and, of course, Marcia Tucker. I am also indebted to the work of Kathy Brew, David Levi Strauss, Kristine Stiles, and Tony Morgan for their excellent contributions to the catalogue. The technical expertise of photographer Ben Caswell and video engineer Dieter Froese were crucial to the catalogue and the exhibition. Finally, I respectfully appreciate the energy and support of curatorial interns Moni Ozgilik and Sefa Saglam, and the gracious participation of the artist's assistant, Melissa Moreton. This exhibition would not have been possible without the invaluable support and trust of the artist, whose perseverance and integrity continue to be an inspiration for many, not least of all me.

Dan Cameron

I would like to acknowledge the contributions by the following persons to the separate projects in *Up To And Including Her Limits:* Kerry Brougher, Los Angeles; Penine Hart, New York; Emily Harvey, New York; Giles Herbert and Wayne Baerwaldt, Winnipeg; Max Hutchinson, New York; Hubert Klocker, Vienna; Ursula Krinzinger, Vienna; Samuel Lallouz, Montreal; Bob Riley, San Francisco; and Elga Wimmer, New York.

A special mention of those photographers who have died, but whose images continue to enrich the visual history of my work: Peter Moore, Al Giese, and Tony Ray-Jones.

Video collaborators on this exhibition have been Maria Beatty, Miroslaw Rogala, and Victoria Vesna. Technical assistance was provided by Tom Brumley, Jay Dunn, Michael Joseph, and Doug Propp, as well as by Marvin Soloway of Guffanti Film Labs.

I am very grateful to Melissa Moreton, Joan Hotchkis, Kristine Stiles, Kathy Brew, Jay Murphy, Sara Seagull, James Tenney, Lauren Pratt Tenney, Robert Morgan, Anthony McCall, Peter Huttinger, Bruce McPherson, and Gale Elston, Esq. for their support. Very special thanks to James Schaeffer, Vesper, Oskar Kollerstrom, Eve Bailey Lerner and, always, my parents.

Carolee Schneemann

Introduction

In the early 1960s, as a graduate student in art history at NYU's Institute of Fine Arts, I was immersed by day in Greek and Roman monuments, Medieval manuscripts, and early Flemish painting; by night, I was a habituée of Judson Memorial Church, the City Hall Cinema, Max's Kansas City, and the Filmmaker's Cinemathèque, where events, Happenings, and films by artists such as Robert Whitman, Robert Morris, Claes Oldenburg, Stan Brakhage, Robert Rauschenberg, and Andy Warhol were seen and enthusiastically debated. By the mid 1960s, performance played a major role in the New York art world, yet women were a conspicuous minority on the scene. It was only after 1968, when the first wave of the Women's Movement hit New York, that pieces by Meredith Monk, Yoko Ono, Rachel Rosenthal, Yvonne Rainer, Hannah Wilke, Shigeko Kubota, Charlotte Moorman, Joan Jonas, Carolee Schneemann, and others began to take on the accumulated force of a shift in collective thinking about art.

Certain things stand out in my mind about that period, from around 1968 to the mid-1970s. One was how prevalent the body had become as the material of art. It was, after all, a period when phenomenology was in the air (particularly through the writings of French philosopher Maurice Merleau-Ponty), with its focus on the immediate experience of the corporeal body rather than rational thought as the primary means of understanding the world. Bruce Nauman's films, video and "performance" pieces, which used such commonplace activities as pacing his studio floor, were becoming well known in Europe and America; Yvonne Rainer's dances, in which people walked, bent over, sat and moved things from one part of the room to another, were hotly debated in terms of traditional dance movement; Joan Jonas's investigation of her body as a sculptural object blurred the boundaries between art and artifact, private and public; and Meredith Monk's multiple-sited sound and movement pieces refused categorization as opera, theater, music, or dance.

Carolee Schneemann's work was equally difficult to pin down, but it became controversial and ultimately marginalized because of the way she used her own body; her style was direct, sexual, autobiographical, and confrontational. Her work couldn't be called "conceptual" because it was too raw, too emotive, too immediate. Nor did people perceive its connection to "action" painting, which was firmly rooted in the heroic, male tradition. And there was very little familiarity on the part of the New York art world with the work of her European counterparts — Valie Export, Hermann Nitsch and Rudolf Schwartzkogler in Austria, and somewhat later Gina Pane in France and Marina Abramovic in Yugoslavia.

Schneemann's work, in the context of early feminist art activities, was viewed by many at that time as liberating; nonetheless, it ran counter to prevailing feminist politics because it didn't seem to constitute a critique of patriarchy. It had a little too much pleasure, a little too much (hetero)sexuality, and an uncompromising refusal on the part of the artist to justify herself to anyone.

The New Museum's earlier exhibitions and programs provide a context and rationale for presenting Schneemann's work now, when it is possible to see clearly not only the trajectory of her ideas and the context in which they evolved, but their importance and influence for a younger generation of artists. Issues centering on the relationship of art to everyday life, as manifested in performance work of all kinds, have always been central to The New Museum's programming, from the presentation of Jeff

Way's metamorphic "dance" pieces in *New Work/New York* (1978), to *Choices: Making An Art of Everyday Life* (1986), to Bob Flanagan and Sheree Rose's *Visiting Hours* (1994).

Similarly, the interface between art, feminism and performance has been explored in a variety of contexts at The New Museum, ranging from Gina Wendkos's *Four Blondes* (1980), a performance on the sidewalk outside our 14th Street Window, to presentations by Carmelita Tropicana and Penny Arcade. In between, we've presented innovative pieces by Jo Harvey Allen, Linda Montano, Jana Sterbak, Ann Hamilton, the V-Girls, Adrian Piper, Ethyl Eichelberger, DanceNoise, Jerri Allyn, Reno, the Living Paintings, Marina Abramovic, Mona Hatoum, Alva Rodgers, and Laurie Parsons, as well as major exhibitions that centered on specific feminist issues, such as *Difference: On Representation and Sexuality* (1984-85); *Girls Night Out* (1988); Mary Kelly's *Interim* (1990); and *Bad Girls* (1994).

Today the emergence of the body as central to artistic concerns across disciplines, and the reexamination of performance as key to feminist and postmodernist practice in the late 90s, make an exhibition of Carolee Schneemann's work especially relevant. I'm grateful to Senior Curator Dan Cameron for having initiated and organized the first major exhibition of her work, and I'm delighted that The New Museum is the site of this long overdue recognition of her unique contribution to the field.

Marcia Tucker, Director

In the Flesh

Dan Cameron

This presentation of Carolee Schneemann's work, more than three decades after her leap to the forefront of the cultural establishment's awareness with the watershed performance work *Meat Joy* (1964), is inspired by the need to meaningfully assess the influence her work has had and continues to have on artists who have emerged during the present decade. The urgency of this need is perhaps an authentic example of those rare occasions in art history when an artistic development that challenges accepted practice and has thereby been deliberately and systematically confined to the margins of collective discourse is suddenly rushed to the forefront decades after the fact, carried aloft on the shoulders of a new generation eager to identify with the purported act of transgression that led to the earlier artist's exclusion in the first place.

While this interpretation has the added attraction of maintaining the old avant-garde mechanism for valorizing the present generation's taste and insight at the expense of our forebears' lack of same, it does not seem sufficient to address the range of issues that arise when the artist is a woman, and her search for artistic meaning leads her to employ her own body as both the vehicle for her art and the locus of its expression. Among these issues, one of the most pertinent in terms of the motivation behind this exhibition is an attempt to come to terms with the art world's continuing exclusionist policies, especially in cases when the content of

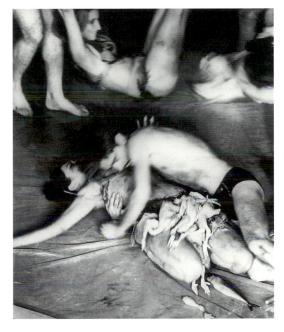

▲ *Meat Joy*, November, 1964, Judson Memorial Church, New York, performance view. Photo: Al Giese

the work directly explores the possibility of inclusion, whether by way of gender, race, and/or sexuality.

Precisely because she pioneered the broad terrain of artistic practice that is encompassed in today's terms in performance, installation, and video, as well as myriad uses of the body, feminist issues and sexuality, Schneemann's work becomes key to a larger mission — to gain credibility for these areas today. The continuing refusal to include her art in historical reappraisals of the period in which Schneemann's work was at its most "transgressive" — the 60s and 70s — reflects a numbingly conformist art historical interpretation of the same period. This unfortunate set of conditions has not only left the public ill-equipped to experience Schneemann's equally challenging works of the past decade, but has also obstructed the current generation's attempts to articulate its unique relationship to the recent cultural past.

This last point bears emphasizing because in order to understand the role that issues of meaning and its exclusion play in the present examination of Schneemann's art, it seems necessary to offer the possibility that the current collective impulse to re-think her work of the 60s and 70s stems from a desire to look at how and why Schneemann's development took the turns it did. In so doing, it is possible to pinpoint its radicality to provide insight into ways in which the issues her work addressed then continue to be manifested in the output of artists working today. It is vital, therefore, that these works not be read as an effort to convey a nostalgic view of the art world of the 60s and 70s, nor even of the artist's unique role within it. Rather, it is inspired by a series of questions that have gradually become more insistent as time continues to lapse between present-day questions about art's relation to lived experience, and Schneemann's initial exploration of the cultural and theoretical problems on which her work is based.

At the most basic level lies the question of specific practice. What was the process by which a painter and maker of assemblages expanded her sense of space and identity to such an extent that she literally became incorporated into her own frame? At a somewhat deeper level of engagement, we find the question of the body's positioning in relation to the subject. With so much performance and installation work addressing the issue of lived experience, how and why was the threshold first crossed between the artist engaged in living her life and the production of work which emerges directly out of themes that are integral to that process? Finally, and with the greatest caution, we come to the problem of the body in history. How does the human vessel as medium project itself across time? And if its innovators do in fact represent a new development in cultural expression, can the body discover its capacity for conveying all of the things its interpreters would have it signify?

The historical weight of these questions would have felt much lighter only ten years ago. Before Carolee Schneemann's example, the likelihood of artists transforming themselves into vehicles for their own art seemed remote. Although the practice became more commonplace in the 1970s, continuity was lost between that experimental decade and the more assertive 1980s. In the more distant past, those visual artists who occasionally strayed into the area of live self-portraiture, or who predate Schneemann in their use of live performance as a vehicle for public provocation — Salvador Dali, Yves Klein, and Claes Oldenburg all come to mind — tended to work under the assumption that their art only made use of these subjects and practices, while its greater significance lay in a much deeper dedication to the more acceptable principles of the avant-garde. In contrast, the boldness of Schneemann's first mature gestures stems from her tacit declaration that the body is invariably the first point of contention in any debate concerning representation. In particular, by championing the validity of sensual pleasure in an increasingly puritanical society, she also challenged some of the most closely held assumptions in the art world (and, by implication, the larger cultural establishment) about how meaning is derived from visual experience. For this reason, growing portions of that community have taken on many of the same concerns that she first articulated three decades ago, in the process transforming them into collective issues.

* * *

Even viewers familiar with the power of Schneemann's signature work from the 60s and 70s are often surprised to discover the struggle in her formative works to come to terms with the Abstract Expressionists. As a young painter arriving in New York in the early 1960s, Schneemann understandably grounded her first canvases in a quasi-figurative, de Kooning-like style painstakingly developed over the course of her

studies at Bard College and the University of Illinois. In retrospect, however, a strong case can be made for this stylistic identity being precisely what Schneemann kept fighting against as a means of forging her own

▲ *Music Box Music*, 1964, Wood, glass, mirrors, paint and music boxes, two units: 12 x 16½ x 9″ and 11 x 15½ x 10″. Photo: Charlotte Victoria

artistic identity. Once the leap into mixed media took place in 1960, her work's slow metamorphosis from static art into an increasingly performance-like idiom was still regularly punctuated by apparent attempts to find solace in pure painting. But even in certain earlier works, there are unmistakable hints of what is to fol-

low. The strength and sensuality radiating from her 1958 portrait of Jane Brakhage Wodening, nude with her arms akimbo, suggests the artist in the midst of an action performance which is still years in the future, just as a 1957 painting based on a Pontormo drawing contains gestures that the artist would put to use in her later preparatory drawings for actions and events.

It is no coincidence that the year of Schneemann's transition into full-blown box constructions, 1960, was the same as that of her first public performance, *Labyrinths*. This fundamental connection, in fact, underlies most of her oeuvre: from the beginning, the uniqueness of Schneemann's work as a performer stemmed from her painter's vision of space as an expanded combine/assemblage, with her physical self becoming an active element within the larger composition. To be more specific, the kinds of liberties that she has taken with herself and her co-performers, while evidently grounded in the experiments of Happenings and Fluxus, appear to have even deeper roots in the primordial material the Abstract Expressionists wrested from the subconscious, with one image

continually feeding off another in a process of layered, ritualistic revelation. This connection influences the way we see Schneemann's 60s box constructions today. At first they seem influenced both by the strong presence of collage and assemblage in the trends of the moment, as well as by her admiration for (and later friendship with) Joseph Cornell. Still, the rapid evolution that takes place in the studio work from 1962 to 1966, parallelling Schneemann's breakthrough as a performance artist, tempts us to view constructions like *Native Beauties* (1962-64) and *Music Box Music* (1964) as something like miniature settings where experiments in movement and interaction are shared with an audience that is as much a part of the experience as the performers.[1]

One of the most significant outside factors in Schneemann's move towards performance as a natural vehicle for her sensibility was the close interaction among the avant-garde art, poetry and music communities in the early 1960s.[2] Within those same communities, the almost Utopian structure of Allan Kaprow's Happenings from 1959-62 had provoked a number of other younger visual artists to begin looking towards performance and environments. Claes Oldenburg's *The Store* environment (1961-63) and his accompanying *Store Days* performance (in which Schneemann participated), as well as Jim Dine's *The Car Crash* (1960) were the most spectacular examples of how a new artistic spirit, which would later be divided up between Pop, environments and the new performance vocabularies, was first making its presence felt. Between Schneemann's first foray into participatory

▲ Claes Oldenburg, *Store Days I*, [with Carolee Schneeman as performer], February 23-24, 1962, New York, performance view. Photo: Robert R. McElroy

and event-based work in 1960 and the first of three years Schneemann spent choreographing and later performing regularly as part of the fledgling Judson Dance Theater in 1963, this pre-existing element of interest on the part of the art world had begun to ferment into a truly crossover aesthetic.

Judson, in particular, brought together the experimental vanguards in theater, music, dance, and art. It began in 1962 as an offshoot of classes then being given at the New School for Social Research by choreographer and dance educator Robert Dunn. Held intermittently in the basement of Judson Memorial Church, the loosely-knit group who performed at Judson Dance Theater would later include visual artists such as Robert Rauschenberg, George Brecht, and Robert Morris — who added to Schneemann's notoriety by featuring her as Manet's *Olympia* in a 1965 tableau vivant. But its more recognized historical impact is as the venue that first presented the postmodern choreography of Yvonne Rainer, Trisha Brown, Steve Paxton, Elaine Summers, Lucinda Childs,

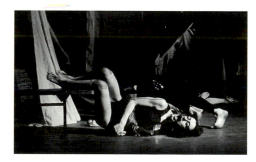

▲*Glass Environment for Sound and Motion,*
[with Yvonne Ranier as performer] May 12, 1962,
Living Theatre, New York, performance view.
Photo: Steve Shapiro

Deborah Hay, and others. Although Judson did not serve as Schneemann's sole outlet for event-based environments, it was the first to provide a sympathetic context in which her double identity as visual artist and performer began to fully coalesce.

By the end of this first important phase in Schneemann's work, the complex spatial designs, sculptural elements and other visuals for performances like *Ghost Rev* (1965) and *Water Light/Water Needle* (1966), as

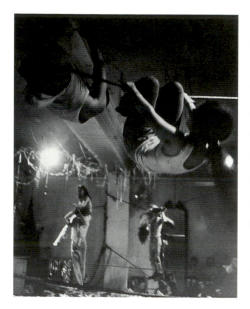

▲ *Water Light/Water Needle,* March 1966,
St. Mark's Church-in-the-Bowery, New York, performance view. Photo: © 1966 A.V. Sobolewski

well as the production of her first film, *Fuses* (1964-67), suggest the totality of Schneemann's conversion into performer. In retrospect, it is clear that this is also the point at which her immersion into more ephemeral forms of expression began to definitively separate her from the increasingly object-oriented movements of the mid-1960s. Whereas most of her (male) colleagues from the visual arts (Dine, Oldenburg, Morris, and to a lesser degree, Rauschenberg) chose to de-emphasize Happenings after their early efforts, most of her (female) colleagues from dance had already begun to immerse themselves in full-time choreography/production (Brown, Summers, Childs). Neither of these positions, however, suited Schneemann's growing interest in multimedia — in particular, the combination of film, performance, environmental sculpture, and autobiography, which occupied her from 1965 to the end of the 1970s . As a result, forging a new medium to contain her expanding artistic identity remained a struggle through the late 1970s; at which point the art world's growing response to performance and feminist issues began to lend her work a long-overdue legitimacy.

One of the most striking characteristics linking Schneemann's early career as a painter and assemblagist with her later development as

a performance, video and installation artist is the strong interest in recycling her everyday life into art, beginning with literal bits of detritus and evolving through more complex interpretations. Rather than serving as mere props, however, these veiled references to her own life soon grew to encompass a personal artistic mandate emphasizing the use of physical intimacy as one of the primary vehicles for Schneemann's poetics and politics. This metamorphosis in the years 1963-65, from a diaristic presence within the box-constructions to the orgiastic scenarios of *Meat Joy,* might seem a stretch were it not for the early but unmistakable signs of upheaval in social and sexual mores taking place at the same time, expressed as much by the constant challenges to obscenity laws made by writers, performers and artists as by the bohemian standards of the anti-war and counterculture movements. In keeping with the times, participants in Schneemann's mid-60s pieces like *Meat Joy* and *Water Light/Water Needle* did not interact so much as they entangled themselves in one another's space and bodies, becoming part of a collective activity in which touching or otherwise crossing the threshold of physical distance was fundamental to the process of communication. Seen in this light, one of the unique features of this stage of Schneemann's work is the extent to which performance enabled her to blow up a previously intimist aesthetic to public scale. In the same literal way that the obvious tactile pleasure of her constructions reappears with her arrangements of spatial elements in early performances such as *Chromoledon, Eye Body* and *Lateral Splay* (all 1963), this part of her identity takes on a third aspect in the more elaborate, mixed-media visualizations realized for breakthrough film-performance works such as *Ghost Rev* and *Snows* (1967).

The transgressive aspect of Schneemann's nudity was a key element in the way these issues transcended sculpture and became political acts, charged by the public spectacle of a woman dictating the terms by which her body could be viewed, and in so doing ensuring that her work would be misconstrued. Setting aside more obvious antecedents like Marcel Duchamp's game of chess with a nude woman and Yves Klein's gymnastic manipulations with paint-daubed female "assistants," such an assumption even flew in

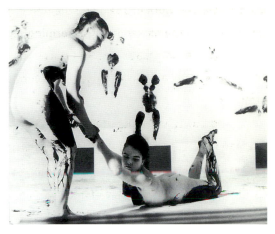

▲ Yves Klein, *Anthropometrie Performance,* March 9, 1960, Galerie Internationale d'Art Contemporain, Paris, performance view. Courtesy Daniel Moquay. Photo: Charles Wilp

the face of previous examples of such imagery by women artists; one of the closest historical comparisons would be Meret Oppenheim's 1959 tableau *Spring Feast,* incorporating a full-scale female nude reclining on a table surrounded by fruit and male "diners." (At its private viewing, both diners and model were flesh and blood.)[3]

In Schneemann's own milieu of the mid-60s, an evening of avant-garde performance could hardly be considered complete without a live nude woman appearing at some point in a piece, invariably one authored by a man. By contrast, one of Schneemann's very first works incorporating performance, *Eye Body,* features the artist nude, displaying a keen erotic imagination as she interacts with various studio materials, using her own painting constructions as the tableau's setting. The direct projection of the artist's sexual energy towards the viewer marks it as a turnabout on the voyeuristic angle of Duchamp's *Étant Donnés,* as well as one of a turbulent decade's most significant transgressions in the accepted canons of modern art. Other works, such as 1964's *Meat Joy,* may have been more

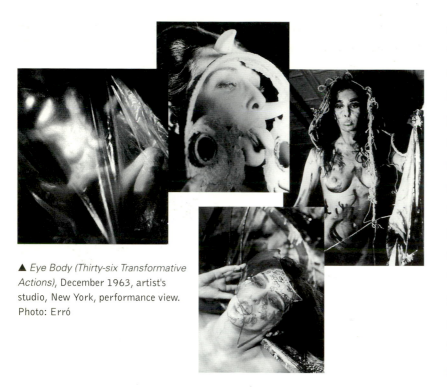

▲ *Eye Body (Thirty-six Transformative Actions)*, December 1963, artist's studio, New York, performance view. Photo: Erró

area — Schneemann's art is probably the most consistent in terms of her focusing her performance persona in such a way that the act of being exposed to the world (and vice versa) never failed to be understood as a highly charged seizing of disputed territory. It was an outrageous act of public eroticism that not only reversed the gender-based hierarchies of representation, but actually challenged the historical dynamic of possession and control between the artist and (her) subject. Despite the fact that certain twentieth-century artists whose work partly prefigures Schneemann's have received, albeit belatedly, some of the recognition due them for their accomplishments (Meret Oppenheim, Frida Kahlo), while others have come to public attention more recently (Tina Modotti, Florine Stettheimer), there is evidence enough to support the thesis that Schneemann and the women artists of her generation were marginalized as a direct result of their successful usurpation of male privilege within the rules of representation. Of course, since one of the other steadfast principles of art history is that the trailblazer usually pays the harshest penalty for having broken the rules, while those who follow are generally guaranteed a much smoother reception, it is not surprising to witness the concerns of Schneemann and her generation being taken up by artists with a very different point of departure.

Up To And Including Her Limits (1973) perfectly embodies these contradictions within the public perception of Schneemann's art. It was produced at a time when she was emerging from a period of disillusionment with the physical and technical requirements involved in the ambitious performances of the late 1960s. Featuring, in its final version, a video playback of the artist suspended for long periods of time from a harness as she creates drawings across massive paper surfaces, the work implies a casting out of unnecessary accoutrements, a rejection of the props and artifice of Happenings and spectacles, and a return to the most

acute in summing up the spirit of the moment, but if we consider the twelve-year period of Schneemann's oeuvre stretching from *Eye Body* to *Interior Scroll* (1975) from the perspective of the final sliver of this century, the most radical and influential aspects of her art reside in her ability to have presented her corporal self to an audience in a way that ultimately transformed how representation and gender were addressed within artistic practice.

* * *

Considered in context with other artists of the 60s and early 70s whose works depended, whether intermittently or not, on their creator's own nude participation — Yoko Ono, Yvonne Rainer, Charlotte Moorman, Valie Export and Hannah Wilke seem the most notable pioneers in this

basic tools of the visual artist: the sensate self, a surface, a mark. That this work first took place in interaction with an apple tree growing in her front yard suggests that Schneemann was also decades ahead of her time in articulating the territory of "real-life" bodily and psychic ordeals that artists of the 80s and 90s would claim as their own. For many years after it was produced, *Up To And Including Her Limits* existed as a kind of legend within the art world, a rumor that was never quite verified because the content of the piece was so unspeakably real that young artists and viewers had a difficult time accepting or articulating their own fascination with it.

If we can draw an inference about the metamorphosis of subject matter from the cumulative impact made in the last decade by the work of artists as different as Cindy Sherman, Janine Antoni, Marina Abramovic, Bob Flanagan, Ana Mendieta, Karen Finley, Sean Landers and Matthew Barney — each of whom have worked in a direct historical dialogue (acknowledged or not) with Carolee Schneemann's art — it is that major paradigm shifts sometimes take place years before they are even recognized as such. Broader sociocultural changes also play a considerable role in these shifts within thresholds of tolerance; but except in the most blatant areas of sexual taboo, they have been a less important factor in the reassessment of Schneemann's art than one might hope. One of the explanations for this relative neglect appears generational: the candor of Schneemann's performance works took on a more overtly politicized feminism during the mid-1970s, at precisely the same moment Barbara Kruger and other artists of her generation began to fuse a savvy knowledge of photomechanical know-how with a cooler, more semiotically precise feminist critique based on mass media. While works such as *Up To And Including Her Limits* have no doubt cemented Schneemann's reputation with young video, performance and/or installation artists of

the early 1990s, the continued reliance of these pieces on established performative modes did little to endear them to the emerging generation of the late 70s/early 80s, whose ambivalent relationship to desire would be most aptly expressed by the birth of a period phenomenon known as the art world "mainstream."

Schneemann's photo-based and installation works of the late 80s and 90s loosely demarcate a third distinct period in her work, one which is grounded in a renewal of her artistic ideas through gradual recognition of her ties to the histories of representational practice. From the photo and drawing-based *Hand Heart for Ana Mendieta* (1986) to the semi-concealed paean to Impressionism represented by the installation work *Video Rocks* (1989), Schneemann's art has begun to directly address questions of time, particularly the parsimonious way it is measured out by art history. Granted, the look and feel of recent room-sized pieces might seem unfamiliar to viewers

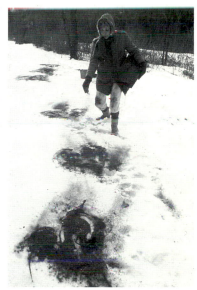

▲ *Hand Heart for Ana Mendieta*, 1986, performance view. Photo: Dan Chichester

whose awareness of the roots of installation art does not encompass early instances of video-based performance, Happenings and environments, nor the complex scenographic ideas developed by Schneemann and other artists of her generation (Robert Whitman, for example). But despite a general reluctance on the part of theorists of the form to bring some of these generational connections to light, the clear trace of Schneemann's history is unmistakable throughout her most ambitious

work of the past decade. Even so, the combination of painting, sculpture, video and performance in a single work like *Video Rocks* entails an unprecedented degree of risk for an American artist in Schneemann's position, suggesting that she is still finding ways to experiment further in the application of her life experience to the projection of new artistic horizons.

The largest space in the present exhibition is given over to a single recent work, *Mortal Coils* (1994), which was originally presented as a solo project at Penine Hart Gallery, New York. Linking her own artistic identity with the lives and visions of numerous artists and cultural innovators, all friends who had died within the preceding two years, the work is blatantly idealistic in the way it links its meaning with an interrelationality of artistic endeavor that runs counter to the image of a community founded squarely on the principle of individual genius. For its author, the principle of mutual entanglement which was brought to the fore in early

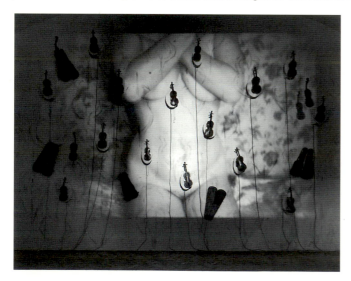

▲ *Cycladic Imprints*, 1991, Mixed media, installation view from the San Francisco Museum of Modern Art, March-May 1991

works such as *Meat Joy* takes on another perspective here, as the impressions of those who have passed on swirl through the darkened space, while unfurled lengths of rope lick at the tiny piles of flour that serve as a metaphor for the space where we live out our earthly lives.

By clearly identifying itself as a summing-up experience, *Mortal Coils* deliberately risks being perceived strictly as a work based on an occasion, lacking the customary affirmation that works of art are generally expected to be permanent. Having emerged from a formative career in which the creation of ephemeral moments and experiences was understood as an honorable way of refuting art's intransigent materialism, Schneemann pays homage to those dear to her by characteristically choosing anti-immortality as a means of embracing the knowledge that creating art about temporality and creating art about the body are ultimately the same thing. Perhaps it is also the summarizing lesson behind Schneemann's art: the first step towards creating something which will last forever is to adamantly refuse to accept our time together as anything more or less than the single fleeting glimpse of a moment which is gone forever the moment it occurs.

Dan Cameron, Senior Curator

Notes

1. It is worth pointing out that this is *not* the way in which Schneemann herself thinks of these particular works.

2. For example, by 1960, the first Living Theater performances staged by Julian Beck and Judith Malina were generally interpreted as broad manifestoes to liberate theater and performance in general, and as such had almost as powerful an impact on the art community of the time as did the early manifestations of the Fluxus movement.

3. Adrian Henri, *Total Art,* (New York: Praeger, 1974), p. 60.

Schlaget Auf: The Problem with Carolee Schneemann's Painting*

Kristine Stiles

> They're afraid I'll pull down my paints…you know…They suspect I get messages
> from my cunt and want to exhibit them.
> Carolee Schneemann in *HOMERUNMUSE* (1977)[1]

Introduction

I would like to introduce the painter Carolee Schneemann, she who is other then, but equally, the pioneer of feminist performance. Other then, that is, than she who has been so commonly portrayed as a taboo-breaking, orgasmic, polymorphous, perverse female whose aggressive personal battles against "erotophobia" are victoriously waged by such blasphemous acts as gently unraveling a text from her vagina in public.[2] So often repeated as to have become a caricature, this representation of Schneemann insidiously distorts her immense personal dignity, casts her simultaneously and paradoxically as an Amazon and martyr, but most of all conceals, while it belies, the diversity and multiplicity of her production. Such an image of her makes it easier to assimilate and appropriate her complex oeuvre within a manageable discourse. "The work of the political activist," Angela Davis observed, "inevitably involves a certain tension between the requirement that positions be taken on current issues as they arise, and the desire that one's contributions will somehow survive the ravages of time."[3] I want to counter the current narrow picture of Schneemann with one of a more considerable art historical achievement in order that her remarkable legacy will survive the partisan positions she needed to take, as well as the ravages to which she and her art have been submitted.

Schlaget Auf

How does one strike at and fell a myth? *Schlaget Auf!* This German verb means to beat, strike, hit, bang, and fell; and, depending upon whether *auf* is interpreted as an independent preposition or a separable prefix of the verb, *aufschlagen,* it can mean (among other things) to burst out laughing or to break open, as in open a book, your eyes, or your heart.[4] What better place to begin than with a laugh that opens the eyes and heart…just where Schneemann's work operates best. *Schlaget Auf* is a work Schneemann performed in 1970 at a Fluxus Fluxorum Festival organized by René Bloch at the Forum Theater in Berlin. It was neither scandalous nor did it have specific feminist content. Probably for these combined reasons it slipped quietly into obscurity. But while an artist's most audacious actions may quickly capture the imagination, her process and mind may be better comprehended and studied in less self-conscious works.

The title *Schlaget Auf,* according to Schneemann, was a mistaken interpretation of Bach's Cantata, No. 53, *Schlage doch, gewunschte Stunde.* The recording was loaded with significance for her. Composer James Tenney, to whom she was secretly married for over a decade, had given Schneemann the 1959 recording (sung by Hilde Roessel-Majden) one "snowbound day in Vermont."[5] The combination of the German music, her German name (meaning snowman) and her nostalgia for that

15

"Whatever I say you will please to translate."

"Was immer Ich sage wirst Du bitte übersetzen."

"Using my body as a tranformable energy system I will demonstrate some recent tendencies of the inter-relatedness between material and movement."

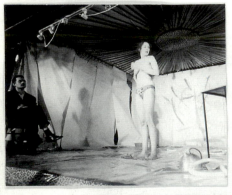

"Indem ich meinen Körper als übertragbares Energiesystem benütze, demonstriere ich jetzt einige neuere Tendenzen in der Wechselbeziehung von Material und Bewegung."

"Our ingredients tonight are a pile of foam rubber strips from the boiler room. Also pints of red, white, yellow grease paint. A dozen Viennese

snowbound day together with Tenney became the catalyst for transferring the contents of memory into action. Underneath its raucous surface, Schneemann's performance was deeply personal. For at the time, she was permanently estranged from Tenney, a period of several years that proved to be one of the most difficult transitions of her life.[6] Adding to her stress and alienation, she found herself in what she described as the "strange" environment of Berlin with what was (for her) the "unrecognizable alchemy" of the Berliners' "reconstituted... psyches."

The elements of *Schlaget Auf* itself are simple. The artist Ludwig Gosewitz was instructed to repeatedly play the bells section of the Bach Cantata and to drop the needle onto the record at intervals he found appropriate. Schneemann began the action by stating that her purpose was to use her body "as a transformable energy system [in order] to demonstrate some recent tendencies of the inter-relatedness between material and movement." Immediately distracting attention from the beauty of her exquisite body, like Aphrodite playing the fool, she stood on a chair both presenting and utilizing her body as a model for the analysis of visual principles. She demonstrated shifts from "linear configurations [to] increasing density of material—organic, rhythmic forms." With great self-mockery in the midst of her own serious narrative, she invited assistants to cover and bind her with foam rubber tubing found in "the boiler room." Completely immobilized in the tubing, still standing on her chair like an absurd model for an academic painting class, she threw herself to the floor in a ludicrous heap. There, seemingly unconcerned, she continued her discussion of the "muscular impulse" of the fall, "in order for the energy of falling to begin moving." Still on the floor, she observed how the buoyant qualities of the foam rubber had permitted "change in the possibilities of movement." The visceral effect of her action was heightened by the pairing of pedantic pedagogy with buffoonery, a juxtaposition that might easily have been read as an ironic allusion to the imperious performance style of Joseph Beuys, then the most visible and influential artist in Germany. Next Schneemann invited volunteers to paint the remaining uncovered parts of her body in greasy colored pigment. Viennese action artist Otto Mühl volunteered for the task.[7]

Finally, she got up and urged the audience to *schlaget auf*, namely to begin pelting her — "the running form"— with Teutonic sweets: "a dozen Viennese pastries, a cream cake, a chocolate cake, a meringue." She called this ending "*schlaget gestalten*," which although not a semantic construction employed in German, roughly translated means something like "to hit a form, shape, or figure."

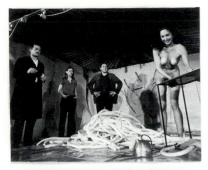

pastries, a cream cake, a chocolate cake, a meringue."

"Unsere Zutaten sind heute abend ein Haufen Schaumgummistreifen aus dem Kesselraum. Ausserdem Dosen mit roter, weisser & gelber Schminke. Ein Dutzend Wiener Gebäck, eine Sahnetorte, eine Schokoladetorte, eine Meringue."

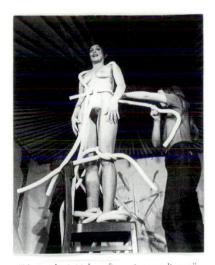

"Notice the initial configurations are linear."

"Beachtet, dass die Figuren (Konfigurationen) linear beginnen."

These pages: *Schlaget Auf*, November 14, 1970, Fluxus Fluxorum Festival Forum Theatre, Berlin, performance view. Photo: Hermann Kiessling

Her allusion to gestalt psychology suggested that the action simultaneously struck on several stimuli, or events, in interaction. Similarly, Schneemann's gestalt aesthetics combined the resolution of methodologically sophisticated formal problems — transforming static shapes (painting) into moving figures (performance) — with riotous behavior.

The semantic complexity of the action was augmented by the simultaneous translation of the words she spoke in English into medieval German. In this way, translation and performance served metaphorical and actual ends, indicating the multiple levels and textures of experience operating within the piece for the artist and the audience. The translation, made by a scholar of medieval German poetry, could mark the historical divide between the past and the present or the cultural gulf separating interpretation, intention, and presentation, as much as it could signify Schneemann's theoretical concerns with the transmogrification of the formal languages of art (painting and sculpture) into human action. She had envisioned just such an aim already in 1962-63 when she wrote: "If a performance work is an extension of the formal-metaphorical activity possible within a painting or construction, the viewers' sorting of responses and interpretation of the forms of performance will still be equilibrated with all their past visual experiences."[8]

Schneemann's extension of painting into performance was inspired by her first muse — not a mythological goddess, but Paul Cézanne. Cézanne's work provided the inspiration that fueled her relentless quest to stretch the boundaries of visual form in order to accommodate what she understood as a craving of the human senses for "sources of maximum information." Her early drawings, paintings, and constructions transparently reveal how she took her cue from Cézanne, especially his "Bathers" paintings. But in her use of materials that cover the body, especially the shredded and collaged newspapers she used in so many Happenings and performances, Schneemann vastly expanded on Cézanne's technique of *passage* by translating and transforming its static patches of interlocking pigments into the moving elements that she became and described in *Schlaget Auf*.

Schneemann's study of the ocular phenomena of painting and seeing led to her formulation of a concept of the eye — the artist's primary tool — as a muscle joined to emotions and able to awaken insight and empathy in the physiological and characterological conditions of being. This aspect of her thinking has been exploited repeatedly by those who link it only to her daring action *Eye Body* (1963) and to the context of feminist reappropriations of the body and female sexuality.

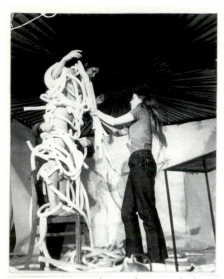

"Increasing density of material-organic, rhythmic forms....Because my legs and arms are tied up I will have to throw myself off this chair!"
"Zunehmende Dichte der material-organischen, rhythmischen Formen... Da meine Beine und Arme gebunden sind, muss ich mich von diesem

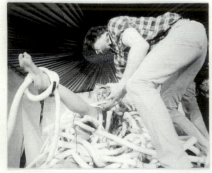

"A muscular impulse, in order for the energy of falling to begin moving."
"Ein Muskelimpuls, um die Energie des Fallens ins Rollen zu bringen."
"The foam rubber bounces. Another tangible element which will change the possibilities of movement....Could I have another volunteer for this grease?" (Otto Muehl obliges.)

But there is another source for such thinking about the eye. It is the gender inclusive manner in which she linked vision to the body and to the vigor of human vitality. This way of thinking about the relationship of the body to sight is, I think, much closer to the broader goals of Schneemann's painterly aims before the theoretical structure of her work became overtly feminist in the late 1960s. This focus on the interrelation between corporeal vision and empathy in the play of human vitality is a legacy of Henri Bergson's concept of *élan vital,* the life force. For what Schneemann actually wrote was that the eye "benefits by exercise, stretch, and expansion...to alert the total sensibility — cast it almost in stress" — in order to "extend insight and...the basic responsive range of empathetic-kinesthetic *vitality.*" Her point, then, was to train the eye (with the assistance of the painter skilled in the instruction of that organ) to reach the empathetic interiority of the body where human vitality may be excited and aroused enough to desire to join more fully in the social conditions of being.

I have used the words excited, aroused, and desire in order to link spiritual conditions (too commonly interpreted in Schneemann's work only in terms of physical sexuality) to the higher sensuality of the body-mind unity which is, I believe, her ultimate purpose. And, moreover, I have emphasized that Schneemann's approach to action is rooted in painting, the wellspring of her art. But it must also be said that the antecedent for *Schlaget Auf* was *Naked Action Lecture* (1968), performed at the Institute of Contemporary Art in London. Although she projected slides of her paintings, constructions, and kinetic theater, as well as projected her film *Fuses* (1964-67), and lectured on her "visual works and their relations to antecedents in painting," the action was charged ideologically with feminist questions she posed to the audience, while dressed, undressed, dressing, and undressing.

Can an art istorian be a naked woman?
Does a woman have intellectual authority?
Can she have public authority while naked and speaking?
Was the content of the lecture less appreciable when she was naked?
What multiple levels of uneasiness, pleasure, curiosity, erotic
fascination, acceptance or rejection were activated in an audience?[9]

There is no doubt that such questions would become the cornerstone of her feminist work from the mid-1970s on, exactly the same period when her use of the gender-neutral term "istorian" seems to have entered systematically into her vocabulary. The term was a vital one for Schneemann and she

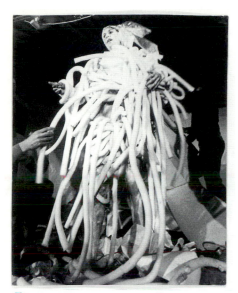

Bewegung verändern wird... Dürfte ich bitte einen anderen Freiwilligen haben für diese Schmiere?"
"Everyone pick a cake! I will start running, you each try to slap a cake on me. Thank you. Music! Lights!"

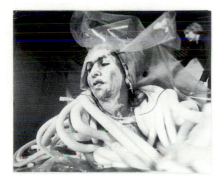

...schlaget gestalten...!

...schlaget gestalten...

discussed it in an exchange of letters with her friend, the poet Clayton Eshleman. He asked if she knew "Olsen's reference to "Istorin" in the Greek as 'the root of history.'" Eshleman then explained an ancient conflict: "Thucydides defined 'history as facts,'" he wrote, "Herodotus defined Istorin as 'the personal search for the real.'"[10] When he aligned Schneemann's use of the term "istorin" with a personal search for the real, the poet fully grasped the scope of her vision as an artist. He correctly contextualized her evolving feminism within the much broader theoretical study she had made of the interrelation between painting and the body's vital conditions of being and seeing.

Schlaget Auf was a transitional work, a hybrid. Part Happening which involved audience participation, and part lecture-demonstration, displaying the artist and her body performing in a proscenium setting, this work occurred at a moment when Schneemann clearly was concerned with emerging feminist issues. But these issues were only part of a larger set of concerns having to do with her research into the heightening of psychical awareness through the intensification of physical experience, a direction that her study, particularly of Wilhelm Reich, took her. Given its density and theoretical richness, it is difficult, on the one hand, to understand why Schlaget Auf could have been forgotten. On the other hand, the work does not lend itself to a more focused feminist concern. Furthermore, it is easy to imagine that the merriment it launched, which was at odds with the seriousness of gender politics, would be overlooked in a tragic culture bent on forgetting that comedy is perhaps the most profound meditation. Schlaget Auf exposes Schneemann at her most brilliant. Emerging from a combination of visual, musical, and textual sources, Schlaget Auf incorporates the same systematic application of theory to practice that, like her drawings and paintings, directly link the artist's creative imagination to her unconscious. Schlaget Auf also offers insight into her ability to grasp the ethos of a particular social moment and locale, and render it visual and material. It is evidence of her wit, spirit, and healthy sensuality in full operation, expressed through the unaffected presentation, manipulation, and transformation of her dressed and undressed body.

Finally, Schlaget Auf is an expression of Schneemann's inability to be anyone but herself.

Not only do I always write what I think, but I have not even dreamed, for a single instant, of disguising anything that was to my disadvantage, or that might make me appear ridiculous. Besides, I think myself too admirable for censure. You may be very certain, then, charitable readers, that I exhibited myself... *just as I am.*[11]

Although these words could have been written by Schneemann, they were not. They belong to the Russian painter Marie Bashkirtseff, whose diary Schneemann read as a young woman. It influenced and informed her imagination about the defiant struggle a woman must undergo as an artist. There is something terrible and wondrous in its (and Schneemann's) fierce romantic, naive, and simultaneously fearless approach to the world and art. All these qualities, I think, may be found in *Schlaget Auf.*

Apples & Stems

Just prior to the purchase of Schneemann's letter archive in 1994 by the Getty Center for the History of Art and the Humanities, I spent two intensive weeks in early June living in her gracious home in upstate New York, the 18th century stone house where she has worked since the 1960s. There I spent my time reading four decades of her correspondence with leading intellectuals and artists working internationally in experimental art, film, music, and poetry.[12] Only in her more cloistered environment did I see the masses of unknown work, covering every medium from drawing, painting, assemblage, and installation, to film, photography, and video, theory, essays, letters, and poetry.[13] Only there did I experience Carolee Schneemann in her element, and only there in her rural and domestic surroundings did I come to understand her environment as the stabilizing force of her being, the source of her creativity, and a critical — but wholly unknown — condition for the production of meaning of her art.

I was stunned by the plethora of her unknown work and I realized that when this textual and visual production becomes public, Schneemann is likely to be ranked among the most remarkable artist-thinkers of this century. Upon returning home, I immediately wrote to a major American museum to propose a retrospective of her art. I suggested that this exhibition would be as much a consideration of the social, cultural, and political climate of international (but especially American) culture over the last forty years as it would be a view of Schneemann's unique contributions to art history. Schneemann could be compared, I suggested, to Maya Deren (in filmmaking), Simone de Beauvoir (in feminist theory), Frida Kahlo (in the creation of original visual representations), and Anaïs Nin (in creative writing); and I promised to "stake my professional reputation" on that declaration. The chief curator's response was swift and brief: "In the case of Carolee," he responded, "we were compelled by the case that *you* (my emphasis) made but, while she may indeed be the stem, we

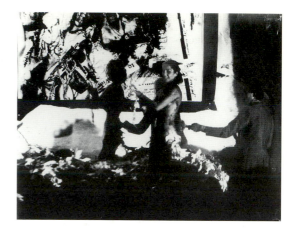

▲ *Naked Action Lecture,* June 27, 1968, Institute of Contemporary Art, London, performance view.
Photo: Charlotte Victoria

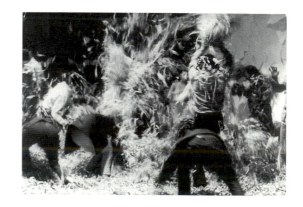

▼ *Illinois Central Transposed,* March 1968, Intermedia 68 Tour, SUNY, Nassau, Long Island, performance view.
Photo: Herbert Migdoll

felt that our audience would be better served by the apple."[14]

The museum official's comment has haunted me for the past two years. That Schneemann could be identified as a stem is fine, but why not the apple, too? What is especially disconcerting is that because the stem is apparently less desirable than the apple, she can be thanklessly appropriated from and simultaneously ignored. For what is a stem if not the main arterial axis, trunk, or body of a tree or other plant that initiates, produces, and supports secondary branches, leaves, flowers, and other appendages? The stem differs from, yet is continuous with, the root in having a capacity for forming nodes, leaves, and buds, and is the term used equally to denote ancestral branches of a family tree. On what basis could he believe that his audience would be better served by Schneemann's artistic progeny, or downright imitators, than by the pioneering artist herself?

In other words, "by what "system of power" are certain representations authorized while others are blocked, prohibited, invalidated, or ignored?"[15] The answer, in large measure, is obvious and tautological. Those representations that reproduce systems of power are empowered. This has been noted by many political theorists and cultural critics, but none so elegantly as Henri Lefebvre in *The Production of Space* (1974).

> Political power and the political action of that power's administrative apparatus cannot be conceived of either as "substances" or as "pure forms." This power and this action do *make use of* realities and forms, however. The illusory clarity of space is in the last analysis the illusory clarity of a power that may be glimpsed in the reality that it governs, but which at the same time uses that reality as a veil. Such is the action of political power, which creates fragmentations and so controls it — which creates it, indeed, *in order to* control it.[16]

The most treacherous authorizations, then, are those most crafty in veiling, or appearing to countermand, their connections to power.

Who are Schneemann's progeny? Who are the apples benefiting from the power that authorizes their representations? Certainly among them must be counted artists like Hannah Wilke, Karen Finley, Kathy Acker, Annie Sprinkle and, more recently, Beth B, whose vulvic "portraits" owe an enormous debt to Schneemann. Artists are not the only inheritors of Schneemann's critical thinking and art. So too are such popular figures as Madonna, cultural theorists such as Judith Butler, Donna Haraway, Avital Ronell, and even men such as performance artist Matthew Barney who, as art historian Edward Shanken has pointed out, "adapted Schneemann's model in his attempt to grapple with male ritual and mythology."[17]

The source of the apple/stem metaphor is the worn-out fable of avant-gardism, a revision of the tale of competitive binaries (stale/fresh, old/new) and the continual process of replacement that it entails. But this myth is remarkable only for the instability of any claims attached to it. Who are the perpetrators of this farce? All of us: critics, art historians, and artists alike who turn the power of art criticism, the effort of artists, and the peerless necessity of art into a commodity co-opting the originality of the stem for the promotion of the apple.

Apples are merely consumer items presented as worthy of museum attention because only the shiny waxed fruit — sanitized for protection — is considered acceptable fare for those who devour culture. A comment made by Schneemann is relevant to this context:

> As a painter you have to *see*. I always felt there was something in a fruit that was as taboo as genitals were — where the stem comes out. You were never forbidden to look in a concavity or convexity of anything that was animal or mineral or vegetable…only human fractures were explicit and therefore taboo.[18]

Apart from the moralistic taboos related to the body that Schneeman

raises here, stems also have to do with the mystery of making — equally a body issue. For the stems retain their gritty, physical connection with the earth, with dirt, with the primary sources of creation. But a culture that measures itself by its material possessions wants little to do with the *techne*, or art, of making, which not only distracts it from its monomaniacal desire to accumulate, but demands an encounter with the body that produces. Objects, especially shiny apples, hold the lure of immortality in their pristine stasis, while the process of making forces one to confront the actual limits of one's abilities. Schneeman's art has always been unmanageable, because it is far too consistent with the raw chaos of her own evolving processes and experiences. This accounts, in no small measure, for why some have felt that their audiences would best be served by an apple than by her stem.

Decorum, or The Problem with Carolee Schneemann's Paintings

I have searched for concepts that would extricate Schneemann's work from postmodernist clichés of sexual and gender resistance, intervention, and transgression because such categories, while they may have once served an important purpose, have become effective tools in the domestication of her art by bringing it in line with an established theoretical discourse that controls, defines, and, most of all, cleans her up. If she may be so easily categorized as a transgressive "bad girl" or an "angry woman," she may also be dropped back into the bushel with the other apples and there will be no need to deal with her complexity.[19]

I do not think that the driving force of Schneemann's work is transgression, even though she does sometimes act across the boundaries of established order. I think her *modus operandi* is much more dangerous than transgression, and far more subtle. She breaches decorum. The concept of decorum is slippery and maintains a very fine semantic border with that of transgression. Discriminating between them, in Schneemann's case, is worth the attempt. For although the two may be fluid, there are special distinctions that I believe will open the discussion of her work to the expansive, generative, and gender-inclusive discourse it deserves.

Decorum signifies social values. The concept seems to have originated in literature where it referred to the appropriate rendering of a character and his or her action, speech, or scenic environment. Farcical characters should speak, for example, in a manner befitting their rank; kings should intone with the elegance and dignity commensurate with their authority; women should be chaste, dignified, and decorative. Aristotle, and later Horace, emphasized the internal propriety (or decorum) of each genre. Concern for conventions of appropriately decorous behavior are found throughout the world from Confucian civic values of justice to Hebrew religious concepts like *derekh eretz*, meaning "correct conduct" or the "way of the land." In general, decorum designates the regulatory conventions associated with social, gender, and class concepts of propriety, good taste, and good breeding that are judged according to how one comports oneself in congruity with one's social standing, self-respect, and self-esteem.

Breaches of decorum are severely, and this is key, almost invisibly punished by the social group to which one belongs or aspires. A breach of decorum encroaches on social mores and conventions; it does not violate a law, and is not nonconformist. A breach of decorum is usually unintentional. A transgression, more likely than not, is intentional. One is ostracized for a breach, excluded for a transgression. Transgression may require legal punishment and repudiation, yet curiously is also often the occasion for celebration. We never celebrate a breach of decorum. It is met with stony, embarrassed silence and followed by rejection that is subtle and deadly. Unlike codified laws, the rules of decorum are rarely written and are generally indefensible in so far as they represent arbitrary, shifting, and

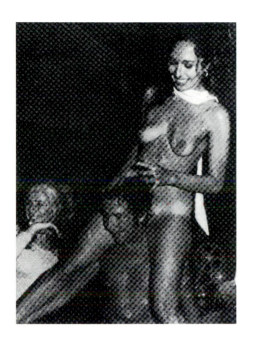

▲ Photograph of Schneemann on Robert Rauschenberg's shoulders. Originally published in *In New York,* "The Super Party," 1968.

▼ *Meat Joy,* November 1964, Judson Church, New York, performance view. Photo: Al Giese

often eccentric modes of behavior. They are quite simply "the way of the land." That's why they resemble so much the values we call "aesthetics."

Schneemann's breaches of decorum are so difficult to reconcile because they are twofold: she has broken with the decorum of the painter, and also with the social codes prescribed for the behavior of female bodies. No better example of this double indemnity could be offered than the outlandish picture of her riding gleefully naked on Robert Rauschenberg's shoulders that appeared in the news section of a journal. What self-respecting painter — especially if she wanted to be taken seriously by a museum, gallery, or other artists, be they male or female — would do such a thing? To make matters worse, one of her most particular, delightful, infuriating, endearing, and unforgivable gifts is to be so fully self-composed that she either appears, or actually is, utterly unaware of her *faux pas* — her breach of decorum. This lack of concern only increases the embarrassed self-conscious discomfort of her detractors.

What I am suggesting is that Schneemann's art and her personality provide a backboard against which we may test our performance of the social/cultural game, be it behavioral or aesthetic. She offers something against which to resist in order to better avoid a confrontation with our own capitulation to the demands of decorum. This paradox is what I think is at the core of her statement: "They're afraid I'll pull down my paints.... They suspect I get messages from my cunt and want to exhibit them." Not unwittingly, she has offered herself up as a kind of inverse shadow-boxer in order for the "istorian" to continue her "personal search for the real." She becomes our imaginary opponent. Her challenge permits us to hide from haunting questions of our own behavior. Inverting our personal demons as projections onto her, we hurl, *schlaget auf,* a Viennese cream pie at her face!

In point of fact, Carolee Schneemann is anything but the Amazonian martyr of our projection and imagination. She lives a structured, very quiet domesticity in an ordered home. When I visited her, our days followed her routine, and ended with walks into the nearby fields and up into the Shawangunk cliffs. Schneemann possesses an aristocratic autonomy and a passionate vulnerability. Separate from the world in her rural quietude, she is, at the same time, intensely engaged in it. "I'm still a little intimidated by Carolee," Lucy R. Lippard once confessed. "She has a regal poise."[20] Lippard's honest awe in the presence of Schneemann prompted her to make what is to my mind one of the most critical observations ever made about Schneemann: "[She] is confident enough to make

messes. How come she's not afraid of the depths?"

The problem with Schneemann's painting, her kinetic theater, is that it requires us to look at the frightening depths of what it means to enter into the reconstituted *passage* of lived rather than observed life, to become aware of the transits between public and private, and to link the false dichotomies of inner and outer, body and mind to the responsibilities of the "istorian" of being. Drawing nourishment from the source of human vitality, her stem blossoms in a profusion of apples while stemming a tide of false codes of received decorum and aesthetics. For a stem does not only refer to a thing that initiates and produces—it is not only the site of the "facture," but also describes a force powerful enough to move forward against, and irrespective of, an obstacle or something adverse: like a ship stemming against a strong current, or like an act that "stems the wild torrent of a barbarous age," a phrase penned by Alexander Pope. The problem with Schneemann's paintings, in fact, is not them, but us. For she has fearlessly unfolded the conventions of painting in order to alter concepts of beauty and truth in a truly troubled age. Gandhi observed that when one is presented with truth, s/he will see beauty. Schneemann's willingness to push for depth is a pledge to truth that is beauty.

Kristine Stiles is an artist and Associate Professor of Art and Art History at Duke University.

Notes

*A large section of this essay has been edited out by The New Museum because it felt that the content (which named names in describing examples of how Schneemann's work has been appropriated inauthentically by artists and critics) was not appropriate for this exhibition catalogue. I regret the absence of this most important section of my work since it directly addressed and grappled with key issues in the way art histories are constructed and reputations made. This section was also crucial in supporting my argument that Schneemann's work has often been acknowledged as the "stem" but overlooked for the "apple" in terms of the misunderstandings and mistaken descriptions of her so-called "transgressive" content and behavior.

1. Text from *HOMERUNMUSE*, first performed at the Brooklyn Museum, New York, November 20, 1977. See Carolee Schneemann, *More Than Meat Joy: Complete Performance Works & Selected Writings*, ed. Bruce McPherson (New Paltz: Documentext, 1979), p. 252.

2. Performance artist Joanna Frueh uses the word "erotophobia" to describe reactions to Schneemann's *Cycladic Imprints* (1988-92), a photographic series of vulvic images. See Joanna Frueh, *Erotic Faculties* (Berkeley: University of California Press, 1996), p. 104. Frueh is by no means the only critic, just the most recent, to characterize Schneemann in this manner.

3. Angela Y. Davis, *Women, Culture & Politics* (New York: Random House, 1984), p. xiii.

4. I would like to thank my colleague Ann Marie Rasmussen, Associate Professor of German Language and Literature at Duke University, for assistance with the philological problems raised by Schneemann's title.

5. Becaues of space limitations in this catalogue, it was not possible to print the entire photo series and text from *Schlaget Auf*. For the full spread of image and text see *More Than Meat Joy*, pp. 208-211.

6. Schneemann alludes only briefly to this period in *More Than Meat Joy*, p. 182: "I'm surprised by a smiling photograph taken at the time (April 24, 1969, during her action *Expansions* performed at the New Poets Theater in New York.) I was falling into the long slide of disorientation and despair. In a few days I was leaving NY for France..."

7. *Schlaget Auf* may have had a direct and immediate impact on Otto Mühl who, at that moment, was in the formative stages of organizing the AA Kommune (Actions-Analytic Commune). Collected around the principles of direct democracy, common property, communal living, free sexuality, and the collective raising of children, after 1972 the group systematically practiced what he called "reality art," or "self-actualization" (*Selbstdarstellung*). These were public presentations of the self with the aim of stripping all pretense in order to break down the normative socialized suppression and construction of the psyche. Mandatory public performances of self-actualization rituals were required by Mühl. Members of the commune performed this process as a key element for psycho-physical healing, and these self-actualization presentations/lecture/demonstrations were often as humorous as they were psychologically painful.

8. Schneemann, "The Notebooks: 1962-1963," in *More Than Meat Joy*, p. 9. All subsequent quotes from this section of "The Notebooks," are from this page.

9. All quotes from *Naked Action Lecture* may be found in *More Than Meat Joy*, pp. 180-81.

10. See Schneemann's note on this exchange in *More Than Meat Joy*, p. 192.

11. *Marie Bashkirtseff: The Journal of a Young Artist, 1860-1884*, trans. Mary J. Serrano (New York: E.P. Dutton & Company, 1919), p. ix.

12. See my forthcoming book *It Only Happens Once: The Letters and Performances of Carolee Schneemann* (Baltimore: Johns Hopkins University Press, 1997). This book belongs to a series on performance art edited by Bonnie Marranca.

13. Schneemann's ability to render her own intimate experience in abstract textual harmonies of unexpected juxtapositions of meaning is especially important since language is, as she has said, yet another medium in which she tried to paint: "What I was trying to find was a way to —in effect— paint with words, with video, with film, with the body, with extended structures in space." See "Carolee Schneemann in Conversation with Andrea Juno," in a special issue on *Angry Women, RE/Search* 13 (1991): 67. One of my favorite examples of Schneemann's writing is a section of a letter to James Tenney in which she compared her drawings of Bengal sculptures, Shakti and Shiva, to their love: "My love I found two lovers; dancing stone each other. (A guard laughed to another; "There's a young lady copying a new way to do it in an old way.") I was drawing. Drawing on an embrace of forms: rolling, halting gestures of combination, of meeting, complete, secretively convoluted, clearly tenuous: that something is happening, has happened and occurs again…uniquely, samely extending the mystery it conceals. An embrace emphatically conceived and lucidity sexual. What evolution of forms performs before the sense, repeats and then counters motions so that the figures hold all possible in stone space. I can find us, hear our hours of love, years enfolded." See Schneemann, *More Than Meat Joy*, p. 11.

14. I received the letter August 1, 1994. The author's identity must remain anonymous.

15. Margaret R. Miles, Professor of Historical Theology at Harvard Divinity School asked this question in her book, *Carnal Knowing: Female Nakedness and Religious Meaning in the Christian West* (New York: Vintage Books, 1989), p. 5.

16. Henri Lefebvre, *The Production of Space*, trans. Donald Nicholson-Smith (Oxford and Cambridge: Blackwell, 1991), pp. 320-321.

17. Edward A. Shanken in conversation with the author July 4, 1996.

18. Schneemann in *RE/Search* 13:70.

19. See Marcia Tucker, Marcia Tanner, et al., *Bad Girls* (New York and Cambridge: The New Museum of Contemporary Art and MIT Press, 1994). For a discussion of Schneemann and abjection, see Leslie C. Jones, "Transgressive Feminity: Art and Gender in the Sixties and Seventies," in *Abject Art: Repulsion and Desire in American Art*, eds. Craig Houser, Leslie C. Jones, and Simon Taylor with Jack Ben-Levi (New York: Whitney Museum of American Art, 1993), pp. 33-58.

20. Lucy R. Lippard, "Carolee Naked and Maenadian," in *More Than Meat Joy*, p. 280. All subsequent quotes by Lippard are from this article.

Love Rides Aristotle Through the Audience:
Body, Image, and Idea in the Work of Carolee Schneemann

David Levi Strauss

We prefer seeing (one might say) to everything else. The reason is that this, most of all the senses, makes us know and brings to light many differences between things.
Aristotle, *Metaphysics,* I, I[1]

A critic saw in my last plays an attack on history, the linear concept of history. He read in them the rebellion of the body against ideas, or more precisely, the impact of ideas, and of the idea of history, on human bodies.... As long as there are ideas, there are wounds. Ideas are inflicting wounds on the body.
Heiner Müller[2]

Carolee Schneemann has been putting her body on the line for over thirty years in art. The line is that "threshold of consciousness" where, as Heiner Müller says, "desires and fears reside," making "laughter and crying equally subversive." It is the last line of resistance in the rebellion of the body against disembodied ideas of history, whether political or aesthetic. Working always at this line — this broken line, border, and threshold — has put Schneemann's work as an artist in continuous conflict with history, defined by Müller as "the arrangement of bodies according to a law." Schneemann's work has always involved the arrangement of bodies *against* the law, toward justice. (The law, "that which is laid down," marks the failure of justice.) As Bachofen has it, "Justice and strife coincide. The two are identical."[3]

Schneemann's continued insistence on the rights of the female body and feminine mind in a sex-phobic and misogynist culture have led over time to a radical metaphysics that is equally at odds with social conventions. "She threatens mythological revolution," wrote Lucy R. Lippard, "an anarchy that is neither economically feasible nor socially acceptable. As an emissary from the Goddess she bodes no good for the tightassed backbiting esthetic status quo."[4] So it should come as no surprise that Schneemann's work has often received harsh treatment from theorists and art historians, including feminist theorists and historians, many of whom have charged her with "essentialism" and dismissed her work as being "theoryless." In a conversation with historian Kathy O'Dell in 1994, Schneemann responded to these charges.

My whole problem with theoretical structures has to do with their displacement of physicality, as if there is a seepage or a toxicity from the experience of the body that is going to invade language and invalidate theory. The struggle with my work from the very beginning has been that it's smart work, it's mentally aggressive and assertive. It locates theoretical constructs in the experience of physicality. And that might be called "essentialist." It might be called, in Lacanian terms, "absence and lack." Or in Freudian terms, "envy of male linguistic expressivity." The projections onto the body are my area of investigation and my work is to assault and aggress and claw and shred the projections that surround the experience that's of the body, that encapsulates certain theoretical structures.[5]

This dismantling of projections has necessitated a refusal to remain within established disciplinary boundaries. A pioneer of "performance art," "Body Art," "multimedia," and "site-specific installation" before any of these terms existed, Schneemann's influence as progenitor is so pervasive that it has become invisible. She has repeatedly been accused of being superficial for having moved among so many different media. (Imagine this charge being made against Joseph Beuys, Vito Acconci, or Matthew Barney.) She has worked across media from the beginning — in painting, collage, performance, film, writing, photography, and installation — but has always defined herself as a painter, to insist on the physicality of all her artmaking. (The apparent exception here is writing. But even here the usual characterizations are deceptive. Schneemann's companions in writing have always been poets, and especially those poets for whom the act of writing is manifestly physical: Robert Kelly, Clayton Eshleman, Paul Blackburn, Jerome Rothenberg, Michael McClure, and others. It was the poets, and poet-filmmakers, who first recognized what Schneemann was trying to do in her work. And it was from the poets that I first learned of her.)

In one of her most notorious performances, *Interior Scroll* (1975), Schneemann stood naked, slowly unwinding a scroll from inside her vagina while reading from it, giving a whole new slant to *ecriture feminine*. The text of the scroll is a cut-up of something that first appeared in the film *Kitch's Last Meal* (1973-75). It is a characterization of, and rejoinder to, the dismissive criticisms of Schneemann's films by an unnamed "happy man/ a structuralist filmmaker."

▶ *Interior Scroll,* August 1975, Women Here and Now Festival, East Hampton, New York, performance views. Photos: Anthony McCall

I met a happy man
a structuralist filmmaker
—but don't call me that
it's something else I do—
he said we are fond of you
you are charming
but don't ask us
to look at your films
we cannot
there are certain films
we cannot look at
the personal clutter
the persistence of feelings
the hand-touch sensibility
the diaristic indulgence
the painterly mess
the dense gestalt
the primitive techniques

(I don't take the advice
of men who only talk to
themselves)
PAY ATTENTION TO CRITICAL
AND PRACTICAL FILM LANGUAGE
IT EXISTS FOR AND IN ONLY
ONE GENDER

even if you are older than me
you are a monster I spawned
you have slithered out
of the excesses and vitality
of the sixties........

he said you can do as I do
take one clear process
follow its strictest
implications intellectually
establish a system of
permutations establish
their visual set........

I said my film is concerned
with DIET AND DIGESTION

very well he said then
why the train?

the train is DEATH as there
is die in diet and di in
digestion

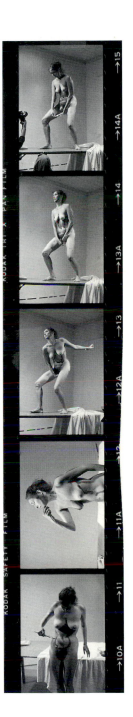

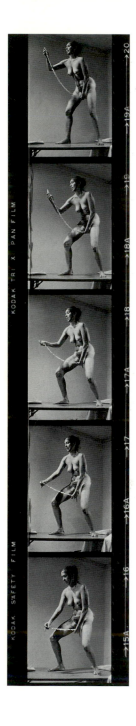

then you are back to metaphors
and meanings
my work has no meaning beyond
the logic of its systems
I have done away with
emotion intuition inspiration—
those aggrandized habits which
set artists apart from
ordinary people—those
unclear tendencies which
are inflicted upon viewers......

it's true I said when I watch
your films my mind wanders
freely...........
during the half hour of
pulsing dots I compose letters
dream of my lover
write a grocery list
rummage in the trunk
for a missing sweater
plan the drainage pipes for
the root cellar........
it is pleasant not to be
manipulated

he protested
you are unable to appreciate
the system the grid
the numerical and rational
procedures—
the Pythagorean cues—

I saw my failings were worthy
of dismissal I'd be buried
alive my works lost........

he said we can be friends
equally tho we are not artists
equally I said we cannot
be friends equally and we
cannot be artists equally

he told me he had lived with
a "sculptress" I asked does
that make me a "film-makeress"?

Oh No he said we think of you
as a dancer.

Interior Scroll was first performed in 1975 before an audience of mostly other women artists in East Hampton. The second time it was performed, the context was quite different. Stan Brakhage had put together a program of erotic films by women for the Telluride Film Festival in 1977, and he invited Schneemann to introduce it. When the festival brochure arrived, giving the title of the program as "The Erotic Woman," and picturing on the cover a drawing of a naked man in sunglasses opening his coat to reveal "Fourth Telluride Film Festival" written across his chest but with his cock and balls erased, Schneemann was incensed. When it came time for her to introduce the film program, she got up in front of the screen, read a short statement, then removed a sheet wrapping her body, applied stripes of mud to her skin, and extended and read the interior scroll once again.[6]

Because Schneemann had lived with the filmmaker Anthony McCall from 1971-76, many of those in the audience at Telluride assumed that the "happy man/ a structuralist filmmaker" was McCall. But in an interview with Scott MacDonald published in 1988, Schneemann made the startling revelation that the *Interior Scroll* text is actually a secret letter to the critic and art historian Annette Michelson, "who couldn't look at my films," said Schneemann. "It's a double invention and transmutation: it's not to a man but to a woman. The projected quotes are from her students."[7]

Now jump ahead to 1994. In a round table discussion titled "The Reception of the Sixties," the editors of *October* (Rosalind Krauss, Annette Michelson, Silvia Kolbowski, Denis Hollier, Hal Foster, and Benjamin Buchloh, with Martha Buskirk) gathered to respond to the negative reception of the Robert Morris retrospective at the Guggenheim Museum by Roberta Smith of the *New York Times* and others. Addressing the different "challenges to the pictorial" that occurred in the 1960s,

Silvia Kolbowski said:

> …a number of women in the 1960s engaged the space of the tableau and the insertion of their own bodies into a tableau-like or pictorial space. For example, the work of Carolee Schneemann or of Valie Export, who contextualized herself by means of a performance, with the residue of that performance surviving as a sculptural piece.

To which Rosalind Krauss replied:

> I certainly agree that challenges to the pictorial within its own domain arose from Body Art — Valie Export is an example, but then so is Hannah Wilke. It had to do with framing the body in relation to the photograph and then performing operations on that photographic representation, which Wilke's work does. So it's true that there were guerrilla actions on the pictorial that were tremendously important.[8]

As the discussion continued, the importance of Body Art by women artists in the 60s, and its "suppression, exclusion, and neglect" by historians and theorists of visual art, became a central topic. Near the end of the discussion, Annette Michelson came to this conclusion.

> But there may be a more general way in which an indictment for the kinds of suppression, exclusion, neglect, that you've mentioned, is in order. Perhaps what's at fault is that historians or theorists of the visual arts have had too minimal a range, have conceived of their task and their field too narrowly. Certainly, the work of the performers of the 1960s, of Yvonne Rainer in particular, has not gone undocumented or unassessed or unevaluated. Together with other work — that of Lucinda Childs and Carolee Schneemann, for example — it has been folded in to that period. But that work has not been done by art historians. It may be that a recent shift from the notion of "art history" to that of a field of "visual culture" may remedy that situation, although we've yet to see abundant and significant results.[9]

Isn't this very much like saying: "We are fond of you; you have made some charming contributions to visual culture, but don't ask us to consider your work in the context of art history?" Is the suppression, exclusion, and neglect of women artists with radical social imaginations somehow built into "the notion of "art history""?

The first illustration accompanying "The Reception of the Sixties" is a photograph of Carolee Schneemann posing as Olympia in Robert Morris's 1964 action *Site*. As the Olympia of Minimalism, Schneemann occupied the site vacated by Manet's model Victorine Meurent, so compellingly tracked in Eunice Lipton's brave book of 1992, *Alias Olympia: A Woman's Search for Manet's Notorious Model and Her Own Desire*.

> The model surveyed the viewer, resisting centuries of admonitions to ingratiate herself. Locked behind her gaze were thoughts, an ego maneuvering. If later on Freud would ask, "What do women want?" then this woman's face answered. You knew what she wanted. Everything. Or rather she wanted, she lacked, nothing. And that is why in the spring of 1865 men shook with rage in front of Olympia. She was unmanageable; they knew she had to be contained.[10]

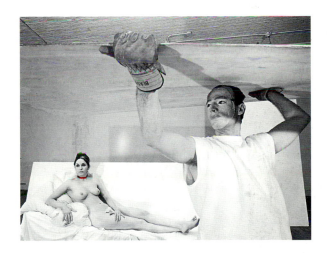

▲ Robert Morris, *Site* [with Carolee Schneemann as performer], 1964, New York, performance view. Courtesy Center for Creative Photography, Tucson. Photo: © 1991 Hans Namuth Estate

◄ Detail from Edouard Manet, *Olympia*, 1865. Courtesy of Musée d'Orsay, Paris.

A hundred years later, when Schneemann moved as a painter off the canvas and outside the frame, she was doing only what was necessary in order not to be contained, as image or as image-maker. She would not be satisfied either with being the object of art or with making detached art objects. She wanted *everything*. Wanting everything meant putting her own body, the object, into the work, always. And it meant "putting her body where her mind is;" that is, refusing the conventional Dionysian/Apollonian split. Artaud was a guide.

Life consists of burning up questions.
I cannot conceive of work that is detached from life.
I do not like detached creation. Neither can I conceive of the mind as detached from itself. Each of my works, each diagram of myself, each glacial flowering of my inmost soul dribbles over me.

Excuse my absolute freedom. I refuse to make a distinction between any of the moments of myself.

This is what I mean by Flesh. I do not separate my thought from my life.

There is a mind in the flesh, but a mind as quick as lightning. And yet the excitement of the flesh partakes of the high substance of the mind.[11]

Unfortunately, the society of the time, including the art world, didn't see it that way, and couldn't see beyond Schneemann's naked body. As Lawrence Alloway observed in 1980, "Schneemann's use of nudity has somehow acted to limit her career, to seal her off in a Dionysian cul-de-sac. In fact her works are flexible and speculative, but the impact of her body has blocked recognition of that fact."[12] It was the impact of her body, and the impact *on* her body of conventional ideas of what a woman's body was for and could do, that made reception impossible. The image obscured the image-maker. Schneemann's refusal to separate the two, to detach one from the other, is an attempt at radical integration that she has sustained for over thirty years. This desire for integration is everywhere evident in Schneemann's approach to visual images; in her endless permutations and manipulations of images of her own body and of the bodies of others, in the splitting, decomposing, and recombining of images, and in her concern for their rhythms and morphologies. Again Artaud:

This is the function of the visual language of objects, movements, attitudes, gestures, but provided their meaning, their physiognomy, their combinations, are extended until they become signs and these signs become an alphabet.[13]

In Schneemann's early silent film *Fuses*, made in 1967, the images of lovemaking (picturing Schneemann and her lover, the composer James Tenney) are cut apart, superimposed, layered, and recombined in rhythmic sequences that reflect an experience of lovemaking that no other film has managed to do, before or since. The action is non-sequential, non-narrative, and doesn't build to a climax. Schneemann's physical manipulation of the film stock — burning, baking, cutting, scratching, painting, coloring, dipping it in acid, leaving it outside in the weather — serves to bring the images through the body. This integration or *fusing* of subject and method, fact and facture, is at the center of Schneemann's practice.

I insist my materials are not fetishistic or romantic but "naturalistic"; I care about their *visual functions*, not their connotations... you have to SEE what they do, not what they are made up of; *the materials function as a way to establish certain visual energies*. Simply that they Are. Smashing glass, throwing resin, setting on fire — these actions were directed to removing or making ambiguous the direct intervention of hand to material — *to combine*

elements out of which a visual fusion would develop beyond my intentions.[14]

And also beyond the artist's intentions came the unbelievably hostile reactions to *Fuses*, a whole series of catastrophic abreactions. Schneemann recalls that when it was first shown at the Cannes Film Festival in 1968, "About forty men went berserk and tore up all the seats in the theater, slashed them with razors, shredded them, and threw all the padding around."[15] And more recently, at the Moscow Film Festival in 1989, the film was banned as obscene and the filmmaker branded as a pornographer, not because the film is sexually explicit (porno films both soft and hard run daily in Moscow), but because it is *politically* explicit, combustible and explosive. As Schneemann says, "Here comes the fire and water; our bodies are the coherence between labor and pleasure, all of a piece."[16] It is that integrated articulation from a woman's point of view that has proven to be perennially unacceptable. What Schneemann considered a philosophical inquiry, the audience took as a provocation.[17]

◄ Stills from *Fuses* (Part I of *Autobiographical Trilogy*), 1964–67. Color film, silent, 16mm, 22 min.

When I made the film of my longtime lover and I lovemaking, basically I wanted to see if the experience of what I *saw* would have any correspondence to what I *felt* — the intimacy of lovemaking. It was almost a Heisenbergian dilemma: will the *camera* distort everything? (There was no camera person present.)

The camera brings back very strange hallucinatory imagery, and it's *not real* — its representations are imprinted on this material and then projected. And to imagine that it's "real," and therefore can be censored, seems to me almost a depraved attitude, because it's not real, it's *film*, and mine in particular is baked, stamped, stained, painted, chopped, and reassembled. And I wanted to put into that *materiality* of film the energies of the body, so that the film itself dissolves and recombines and is transparent and dense — like how one feels during lovemaking…. It is *different* from any pornographic work that you've ever seen — that's why people are still looking at it! And there's no objectification or fetishization of the woman.[18]

The film *Viet-Flakes* (1965), from the same time, performs a similar transformation, but on the images of others. A collection of Vietnam atrocity photographs collected from foreign magazines and newspapers from 1958 to 1964 were laid out in arcs on the floor and then scanned or tracked gesturally with the camera by Schneemann, producing a rough animation, a reanimation of these silenced, stilled bodies. The soundtrack by James Tenney collages Vietnamese religious chants and secular songs with fragments of Bach and American pop

▲ Still from *Viet-Flakes*, 1965. Black-and-white toned film, sound collage by James Tenney, 16 mm, 11 min.

songs of the time. *Viet-Flakes* is a profoundly moving meditation on the effects of history on human bodies, and a poignant attempt to recollect the shards, to put the shattered bodies back together again.

The most difficult challenge to an art based on the primacy of the body and physicality is the body's ultimate transitoriness. Bodies are always disappearing. For this reason, Schneemann's work moves back and forth between joy and grief as between magnetic poles. The grief (source of all anger) arises in the work as an acute awareness of and response to the effects of disintegration — on images, materials, relationships, and on the physical mortal body. And the joy arises from moments of integration — in love, art, body and mind.

The recent installation *Mortal Coils* (1994) is a work of memory and mourning. Schneemann's images of faces and bodies of fifteen friends of hers who all died within two years' time (Alf Bold, John Cage, John Caldwell, Juan Downey, Lejaren Hiller, Derek Jarman, Joe Jones, Marjorie Keller, Barbara Lehmann, Peter Moore, Charlotte Moorman, Frank Pileggi, David Rattray, Paul Sharits, and Hannah Wilke) are projected along with images of totemic objects and body parts related to each person. Motorized mirrors split the projections and scatter them around the room, like shards of a disintegrated picture, while coiled ropes turn slowly in the light. It is a study in grief, an attempt to reanimate the lost bodies, to recover their physicality.

In a statement for the 1993 exhibition, "Action/Performance and the Photograph," Schneemann addressed the importance of the photographic image in her work.

My various works begin as drawings and all eventually take form as photographs, slides, film, video — either as the primary material of the work itself, or as its documentation. As a visual artist/ performance artist, I am both a photographer and a subject for photographers. Photographic media bridge the public act and its private appraisal, the private act and its public dissemination. When the entranced action is over, the photographers have disappeared, when a cultural attribution is in question, or research is

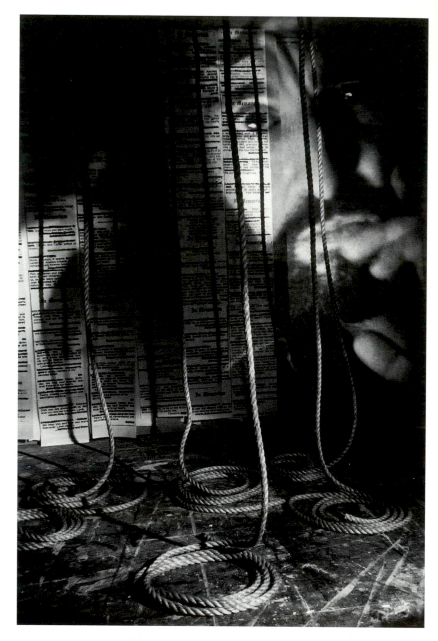

▲ *Mortal Coils*, 1994, Mixed media, installation view from Penine Hart Gallery, New York, March 1994. Photo: Melissa Moreton

stymied, a painting destroyed, a friend has died — in all cases, my photographs remain as source of investigation, quandary, conviction, retrieval and myth.[19]

Schneemann's work has repeatedly involved "framing the body in relation to the photograph and then performing operations on that photographic representation."[20] In a series of recent performances, Schneemann projects slides and then reads out of and into the images. In *Ask the Goddess* (1991), she impersonates the Goddess with tongue in cheek and double axe in hand, performing a sort of divination by slide projection. As people in the audience ask her questions, Schneemann turns to consult the image oracle before answering. In the midst of a good deal of Mae Western hamming (Q: What is the cure for premature ejaculation? A: More of it. The more you do, the less premature it gets.), Schneemann traces the iconographic histories of images of women, men, animals, and of her own performing history.

She instructs one querant to "go back into the body, which is where all the splits in Western Culture occur." She speaks of turning the passive, suspended form of the crucifix into a "re-phallusized, re-energized force," and describes the image of the bull as something that "can work with and for the feminine." At one point she gets up and performs a silly and terrifying dance, blindfolded, in heels, shaking her head to the music. ("We think of you as a dancer.") At times she seems to be in a trance, and the images speak through her, bypassing her intentions.

Q: What is the meaning of art?
A: The meaning of art is destruction. Loss of history, loss of authenticity, loss of integration.

It is not just history and ideas that inflict wounds on the body, but life itself. The integration of labor and pleasure is always momentary and fleeting. The images are all fragmentary, and the bodies keep disappearing. When "Love rides Aristotle through the audience,"[21] we recollect the shards.

Victorine Meurent is reading the Tarot for Carolee Schneemann. The first card drawn is the number two card, the Priestess. Victorine and Carolee raise their eyebrows at one another and laugh. "You can probably have everything you want," says Victorine. "But it will change you."[22] And Carolee replies, "We set each other on fire, we extinguish the fire, we create each other's face and body, we abandon each other, we save each other, we take responsibility for each other, we lose responsibility for each other, we reveal each other, we choose, we respond, we build, we are destroyed."[23] As she finishes speaking, the woman on the face of the card is transformed into a Minoan bull dancer. She vaults off of the card into space, passing neatly between the horns of the bull, leaping precisely from danger to ascendancy.

▲ The Priestess card, Aleister Crowley's Thoth tarot deck. Painted by Lady Frieda Harris. Courtesy of Llewellyn Publications

◄ Minoan "bull-leaping," how the acrobats performed the feat. Courtesy Bell & Hyman Limited

David Levi Strauss is a freelance writer and critic now working in New York.

Notes

1. Quoted as epigraph to the poet Paul Blackburn's book, *In. On. or About the Premises* (New York: Grossman Publishing with Cape Golliard Press, London, 1968), one of the inspirations for Schneemann's *Up To And Including Her Limits*.

2. Heiner Müller in conversation with Sylvère Lotringer in East Berlin, 1981 in *Germania*, ed. Sylvère Lotringer, trans. Bernard and Caroline Schütze (New York: Semiotext(e) Foreign Agents Series, 1990), p. 50.

3. J.J. Bachofen, *Myth, Religion, and Mother Right: Selected Writings of J.J. Bachofen*, trans. Ralph Mannheim (Princeton, NJ: Princeton University Press, Bollingen Series, 1967), p. 187.

4. Lucy R. Lippard, in a jacket statement for Carolee Schneemann, *More Than Meat Joy: Complete Performance Works & Selected Writings*, ed. Bruce McPherson (New Paltz: Documentext, 1979)

5. Conversation with Kathy O'Dell at "Artists Talk on Art," in Soho, December 1994.

6. The program included Agnes Varda's "L'Opera Mouffe," Marie Mencken's "Orgia," Gunvor Nelson's "Schmeerguntz," Anne Severson's "Near the Big Chakra," and Schneemann's own "Fuses" and "Plumb Line."

7. Scott MacDonald, *A Critical Cinema: Interviews with Independent Filmmakers* (Berkeley: University of California Press, 1988), p. 143.

8. Rosalind Krauss, "Round Table: The Reception of the Sixties," *October* 69 (Summer 1994): 10.

9. Ibid., p. 20.

10. Eunice Lipton, *Alias Olympia: A Woman's Search for Manet's Notorious Model and Her Own Desire* (New York: Meridian, 1994), p. 4.

11. Antonin Artaud, *Antonin Artaud: Selected Writings,* ed. Susan Sontag, trans. Helen Weaver (New York: Farrar, Straus and Giroux, 1976), pp. 59, 110-11.

12. Lawrence Alloway, "Carolee Schneemann: The Body as Object and Instrument," *Art in America* (March 1980): 19-20.

13. Artaud, *Selected Writings,* p. 242.

14. Correspondence from Carolee Schneemann to Daryl Chin: Regarding *Up To And Including Her Limits*, May 28, 1975 (Emphasis added).

15. MacDonald, *A Critical Cinema,* p. 141.

16. Carolee Schneemann, interview with Carl Heyward, published in *Art Papers,* (January/February 1993)

17. The sense of "fuses" as combustible and explosive was only one of the senses intended by the artists. The title came to Schneemann and Tenney as a transliteration of the Greek word *fusis,* concerning the order of external nature; natural, physical. *Fusikon* names one of the three branches of early Greek philosophy. The other two are the moral or ethical, and the logical, reasonable, or rational orders.

18. Andrea Juno's interview with Schneemann in *Angry Women, RE/Search* 13 (1991):70.

19. *Action/Performance and the Photograph,* Turner/Krull Galleries, Los Angeles, 1993. Catalogue for the exhibition curated by Craig Krull, essay by Robert C. Morgan.

20. Krauss, *October* 69 (Summer 1994):10.

21. Stage direction in the 1962 score for *Banana Hands,* performed in 1969 by a group of English schoolchildren, reproduced in *More Than Meat Joy,* p. 27.

22. Carolee Schneemann, *ABC — We Print Anything — In the Cards* (Beuningen, Holland: Brummense Uitgeverij Van Luxe Werkjes, 1977). 158 cards, photos and text, boxed. Edition of 151.

23. Schneemann, description of performance imagery of *Snows,* in *More Than Meat Joy,* p. 132.

▶ *Water Light/Water Needle,* March 1966, St. Mark's Church-in-the-Bowery, New York, performance view. Photo: © 1966 Peter Moore

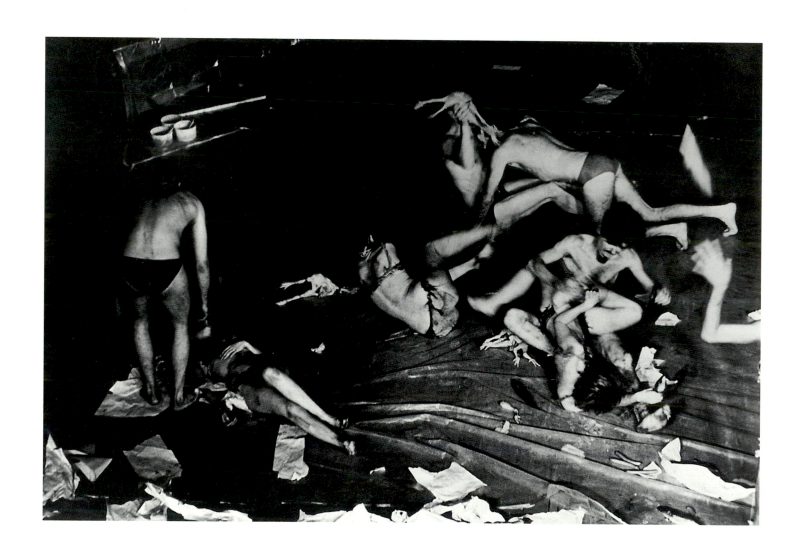

▲ ▶ ***Meat Joy,*** November 1964

Judson Memorial Church, New York, performance view

Photos: Al Giese

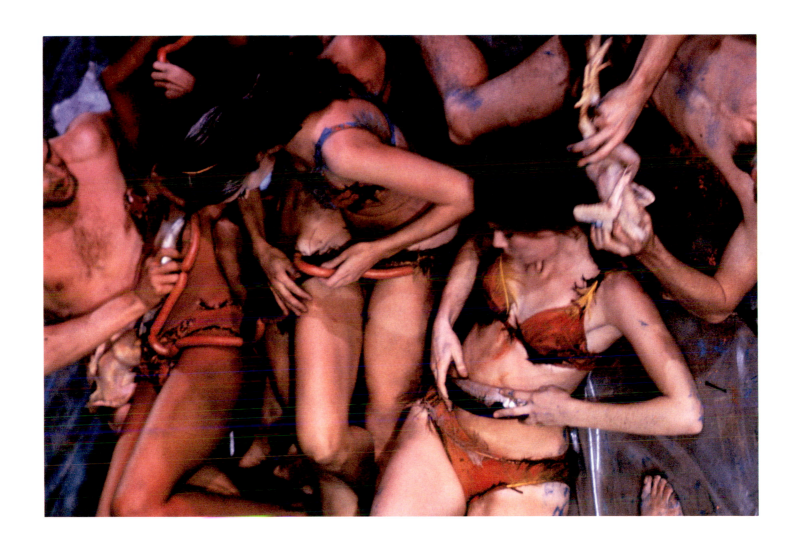

Landscape, 1959
Oil on canvas, 32 x 35"

Pour Lyon (from *Water Light/Water Needle*), June 1965
Crayon, chalk, felt pens, 12 x 18"

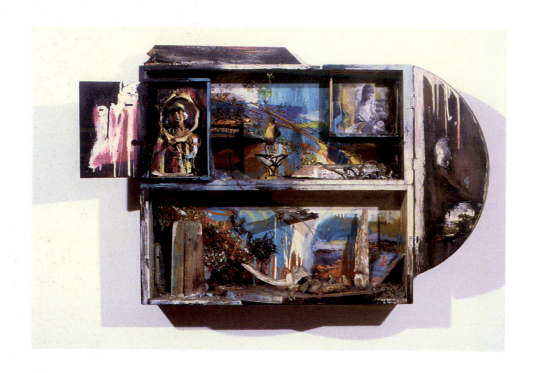

Native Beauties, 1962-64

Construction in wooden box: photographs, Limoges cup, bones, dead bird, 24 x 24½ x 7½″

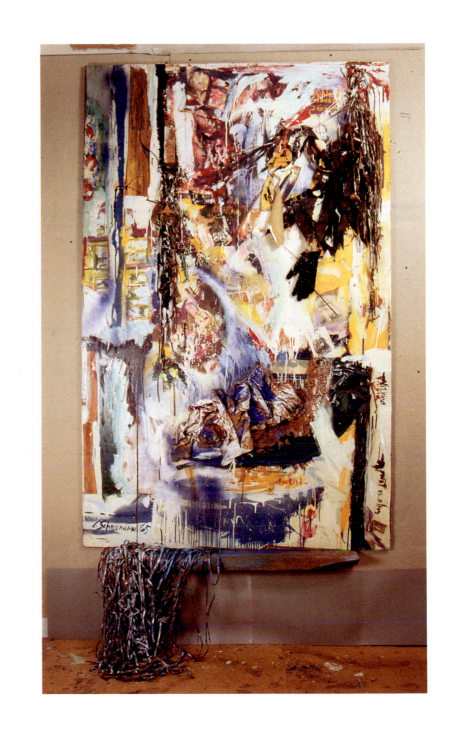

Letter to Lou Andreas Salomé, 1965
Mixed media on masonite, 77½ x 48 x 3½"

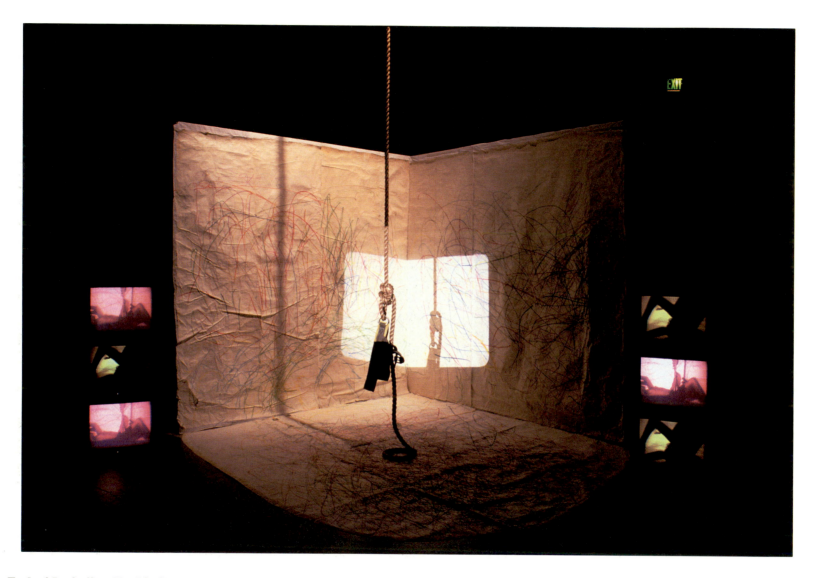

Up To And Including Her Limits, February 13-14, 1976

The Kitchen, New York. Installation view, recreation for The Museum of Contemporary Art,

Los Angeles, "Hall of Mirrors: Art and Film Since 1945," March-July 1996

Courtesy The Museum of Contemporary Art, Los Angeles. Photo: Fredrik Nilsen

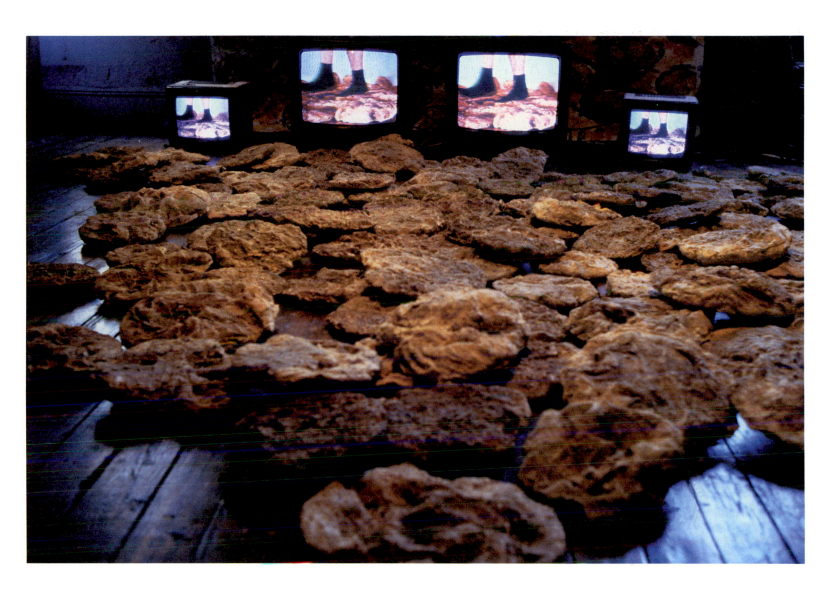

Video Rocks, 1989

Handmade "rocks" (cement, ashes, sawdust, urine, ground glass), lighting rods, four video decks
with eight monitors, and wall-scale canvas (ashes, cement, paint and sand). Studio model

Photo: Hank Guild

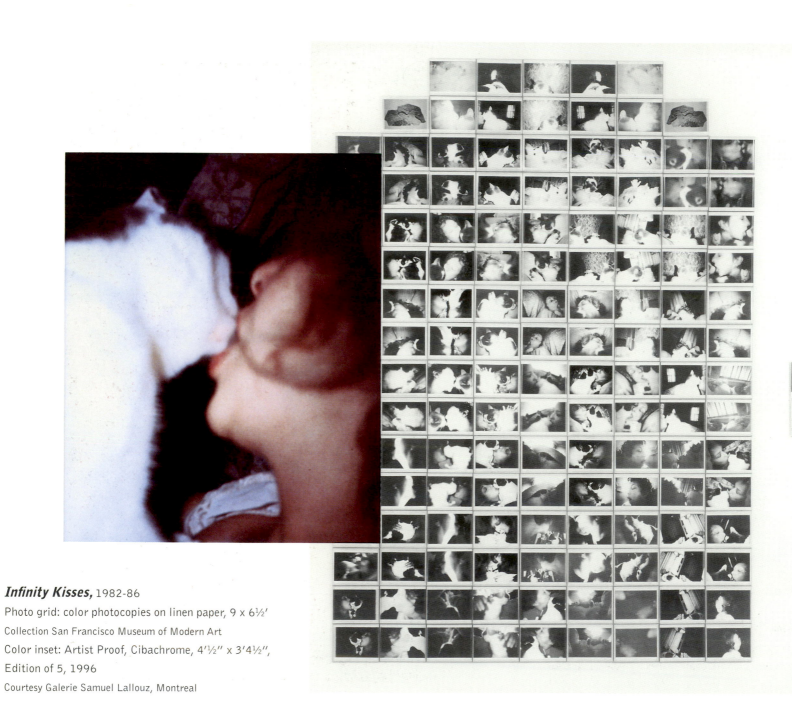

Infinity Kisses, 1982-86

Photo grid: color photocopies on linen paper, 9 x 6½′

Collection San Francisco Museum of Modern Art

Color inset: Artist Proof, Cibachrome, 4′½″ x 3′4½″,

Edition of 5, 1996

Courtesy Galerie Samuel Lallouz, Montreal

 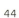

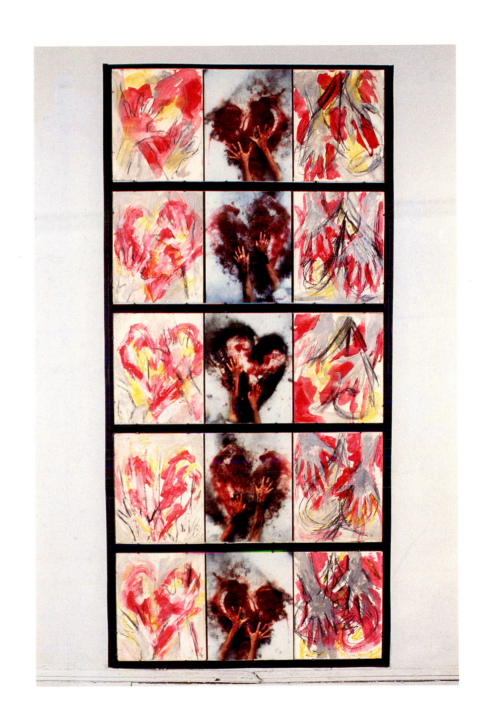

Hand Heart for Ana Mendieta, 1986

Center panel: chromaprints of action: paint, blood, ashes, syrup on snow.

Side panels: acrylic paint, chalk, ashes on paper, 136 x 46"

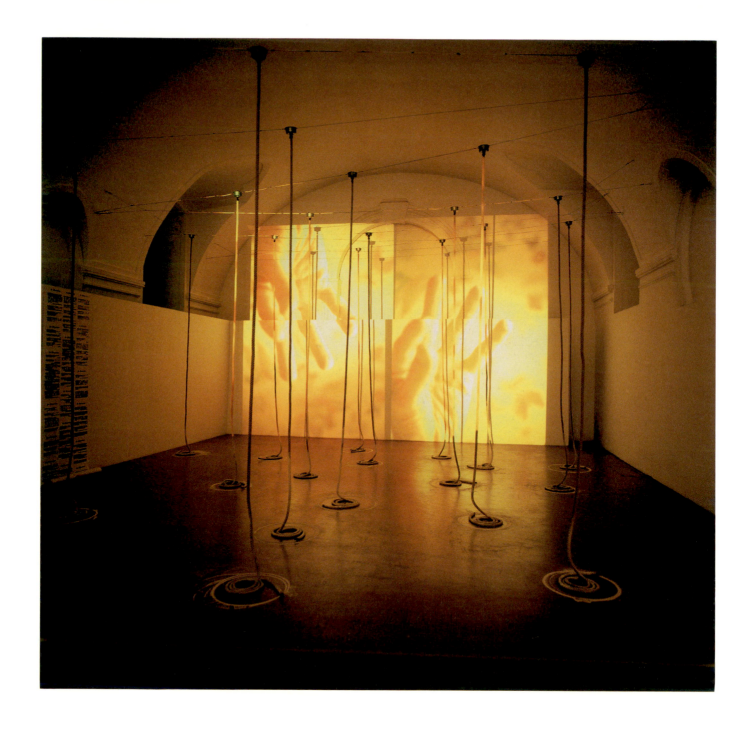

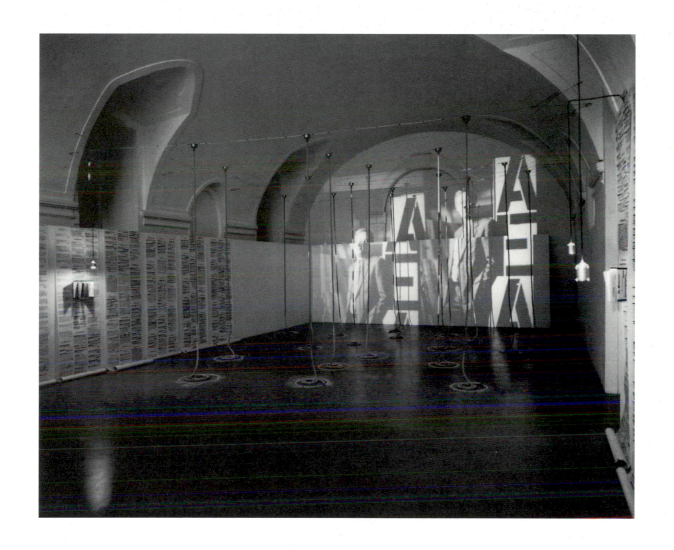

◄▲ ***Mortal Coils,*** 1994

Four slide projectors, two dissolve units, motorized mirrors, sixteen motorized 3/4″ manila ropes,
photo blueprint text, lights, booklets, and flour. Installation view, Kunstraum, Vienna, April-May 1995

Photos: © 1995 Heidi Harsieber

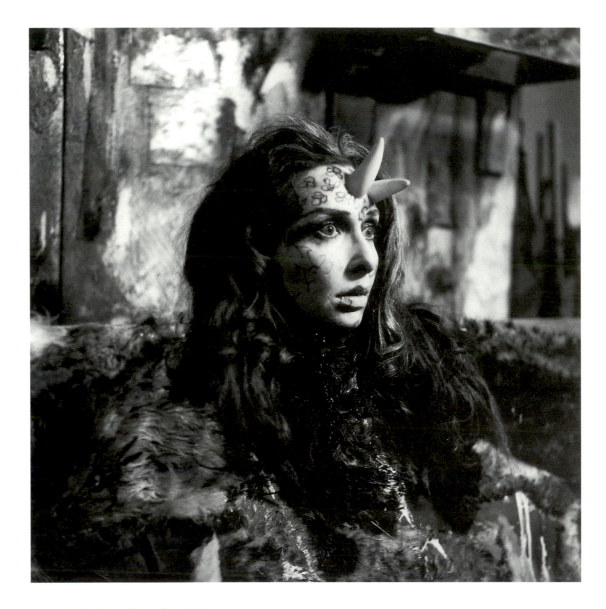

Eye Body (Thirty-six Transformative Actions), December 1963

Artist's studio, New York, performance view

Photo: Erró

Heart Cunt Chamber (from *Parts of a Body House*), 1966
Watercolor, 17 x 14"

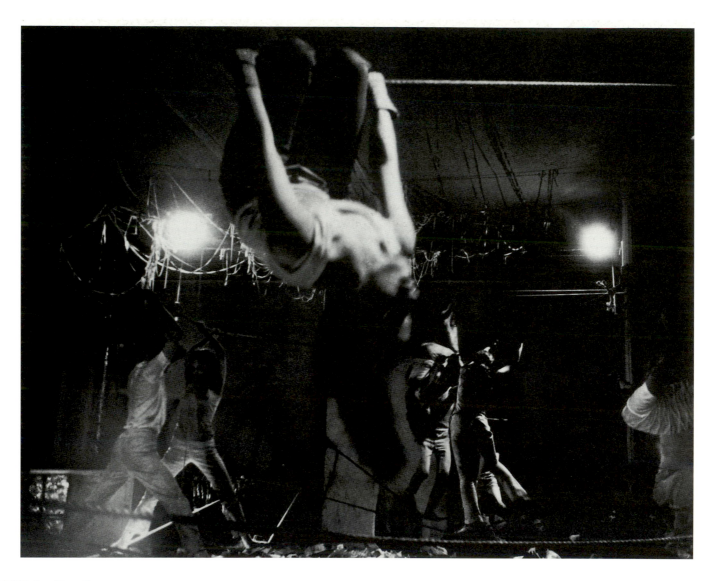

Water Light/Water Needle, March 1966

St. Mark's Church-in-the-Bowery, New York, performance view

Photo: © 1966 A.V. Sobolewski

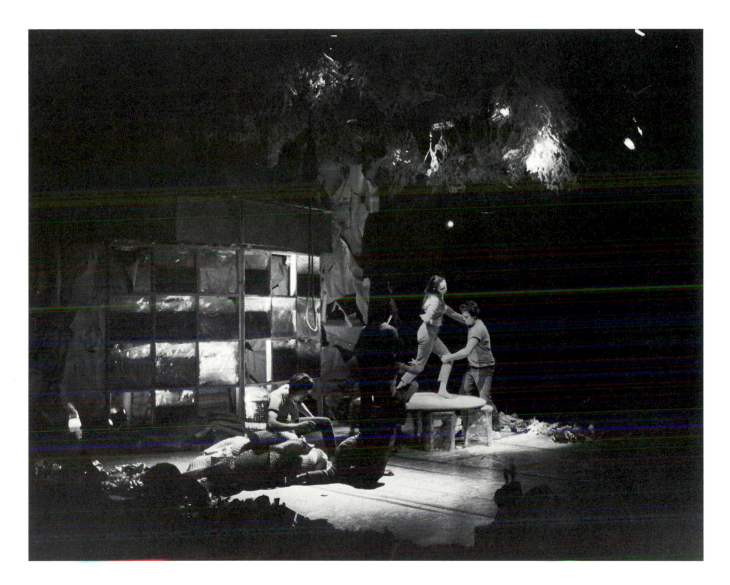

Snows, January-February 1967

Martinique Theatre, New York, performance view

Photo: © 1967 Peter Moore

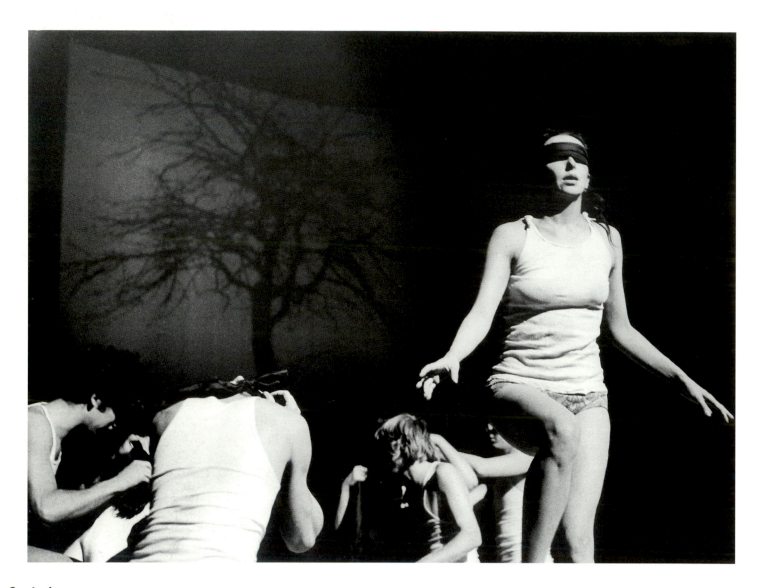

Illinois Central, January 1968

Museum of Contemporary Art, Chicago, performance view

Photo: Peter Holbrook

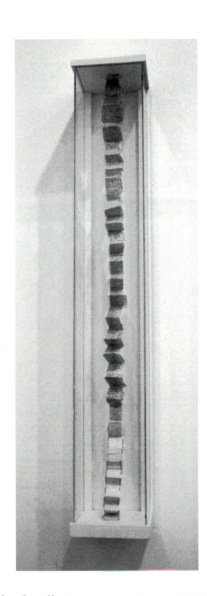

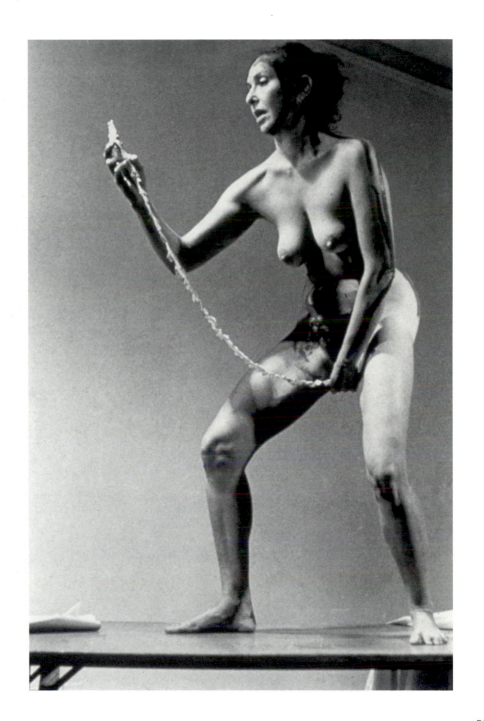

Interior Scroll, first performed August 1975
Photograph, box with paper scroll, 50 x 30 x 10″ (approximate)
Collection Eileen and Peter Norton

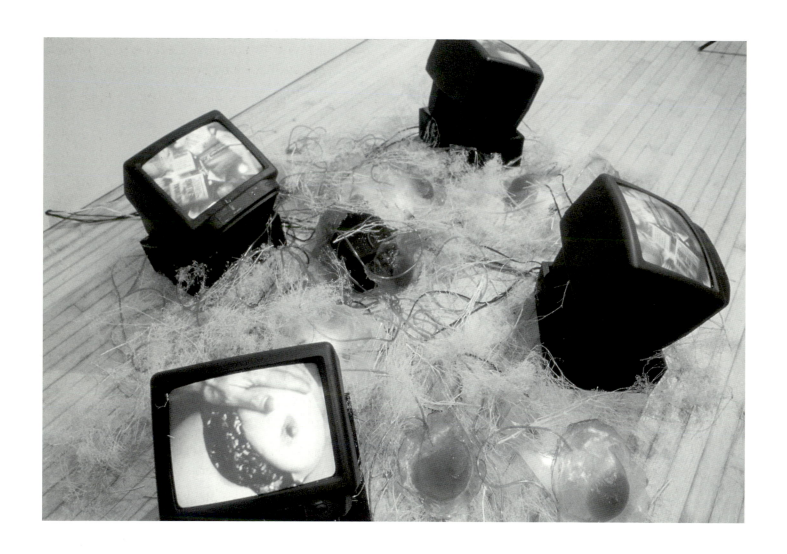

Plague Column, 1996

Video monitor with cast latex breasts, plastic tubing, and lights.

Detail of installation view, Elga Wimmer Gallery, New York, May-June 1996. [Not included in the exhibition]

Courtesy Elga Wimmer Gallery. Photo: Oote Boe

Works in the Exhibition

All works are courtesy of the artist unless otherwise noted.

A) PAINTINGS, COLLAGES, CONSTRUCTIONS, PHOTO-GRIDS

1. *Landscape*, 1959
 Oil on canvas; 32 x 35"

2. *Native Beauties*, 1962-64
 Construction in wooden box: photographs, Limoges cup, bones, dead bird; 24 x 24½ x 7½"

3. *Music Box Music*, 1964
 Wood, glass, mirrors, paint, music boxes; two units: 12 x 6½ x 9", 11 x 15½ x 10"

4. *Letter to Lou Andreas Salomé*, 1965
 Mixed media on masonite; 77½ x 48 x 3½"

5. *Pharaoh's Daughter*, 1966
 Construction in wooden box: lights, slides, paint, clock; 20 x 19½ x 10"
 Private collection, New York

6. *Infinity Kisses*, 1982-86
 Photo grid: color photocopies on linen paper; 9 x 6½' (approximate)

7. *Hand Heart for Ana Mendieta*, 1986
 Center panel: chromaprints of action: paint, blood, ashes, syrup on snow. Side panels: acrylic paint, chalk, ashes on paper; 136 x 46" (triptych)

B) DRAWINGS

8. *3 at One (for Jim)*, 1958
 Ink wash, charcoal and watercolor on paper; 22¼ x 17½"

9. Three drawings for *Chromolodeon*, 1963
 Crayon and pen on paper; 11 x 7" each

10. Six watercolors, one drawing for *Partitions*, June 1963
 Watercolors, 7 x 10" each; charcoal and graphite on paper, 9¼ x 9" (approximate) [unrealized project, shown with text]

11. Four sketches mounted on single sheet from *Eye Body*, February 1964
 Ink and white paint on paper towel; 12½ x 14¾" (approximate)

12. Three drawings for *Bottle Music for Philip Corner*, 1964
 Ink on paper; 10 x 7" each

13. Six watercolors, two drawings for *Water Light / Water Needle*, June 1965-February 1966
 One watercolor, 12 x 17"; one watercolor, 12 x 18"; three watercolors, 12½ x 20" each; one watercolor, 20 x 26"; pencil, oil pastel and felt-tip marker, 12 x 18" each

14. Four watercolors from *Parts of a Body House*, 1966
 "Heart Cunt Chamber," 17 x 14"; "Genital Play Room Cutaway View," 18¾ x 22"; "Genital Play Room," 22 x 22½"; "Liver Room," 22 x 23¼" [shown with text]

15. Five watercolors, two drawings for *Snows*, October 1966
 Watercolors, 12½ x 20" each; ink and chalk, 11 x 8½" each

16. Drawing for unrealized installation, January 1970
 Watercolor and felt-tip marker; 14 x 20"

17. Drawing for installation with *War Mop*, 1982
 Pencil and watercolor; 14 x 17"

18. Drawing for installation of *ABC—We Print Anything—In the Cards*, 1978
 Ink and watercolor; 18 x 23¾"

19. Drawing for *Cycladic Imprints*, August 1992
 Colored pencil, watercolor and felt-tip marker; 11½ x 18"

C) *PERFORMANCE WORKS DOCUMENTED THROUGH PHOTOGRAPHS, NOTES, EPHEMERA*

20. *Eye Body* (Thirty-six Transformative Actions), December 1963, artist's studio, New York
Twenty-eight unique black-and-white prints by Erró, text

21. *Meat Joy*, November 1964, Judson Memorial Church, New York [previously performed in Paris and London] with Sandra Chew, Robert D. Cohen, Stanley Gochenouer, Tom O'Donnell, Irina Posner, Dorothea Rockburne, Carolee Schneemann and James Tenney
Eighty digitized, color photographs by Arman, Al Giese, Robert McElroy, Peter Moore, and Harvey Zucker; seven vintage black-and-white photographs mounted by the photograher Harvey Zucker; seven black-and-white photographs by Peter Moore; six black-and-white photographs by Al Giese; one black-and-white photograph by T. Ray Jones; one black-and-white photograph by Charles Rotenburg; flyer by Carolee Schneemann, program, text [see also 24]

22. *Water Light/Water Needle*, March 1966, St. Mark's Church-in-the-Bowery, New York with Mark Gabor, Tony Holder, Meredith Monk, Yvette Nachmias, Phoebe Neville, Tom O'Donnell, Dorothea Rockburne, Joe Schlichter, Carolee Schneemann, and Larry Siegel
Eighty digitized, color photographs by Arman, John Weber, Herbert Migdoll, and Charlotte Victoria; nine black-and-white photographs by Charlotte Victoria; five black-and-white photographs by Terry Schutté; three black-and-white photographs by Alex Sobolewski; two black-and-white photographs by Peter Moore; unique contact sheet by unknown photographer; flyer by Carolee Schneemann, program, text [see also 25]

23. *Snows*, January-February 1967, Martinique Theater, New York with Shigeko Kubota, Tyrone Mitchell, Phoebe Neville, Carolee Schneemann, James Tenney, and Peter Watts
Eighty digitized, color photographs by Herbert Migdoll, Alphonse Shilling, and Charlotte Victoria; three black-and-white photographs by Paolo Buggiani; two black-and-white photographs by Peter Moore; two black-and-white photographs by Alex Sobolewski; five black-and-white photographs by Charlotte Victoria; five black-and-white photographs by Ted Wester; flyer by Carolee Schneemann, program, text [see also 26]

D) *PERFORMANCE WORKS DOCUMENTED ON FILM OR VIDEO*
[Note: Most films to be shown as excerpts in video versions only, except for scheduled screenings at the Anthology Film Archives]

24. *Meat Joy*, first performed May 29, 1964, Festival de La Libre Expression, Paris
Color film, sound, 16mm, 12 min.
Filmed by Pierre Dominick Gaisseau, edited by Bob Giorgio [see also 21]

25. *Water Light/Water Needle*, March 1966, St. Mark's Church-in-the-Bowery, New York
Color film, sound, 16mm, 16 min.
Filmed by John Jones and Sheldon Rochlin, edited by John Jones and Carolee Schneemann [see also 22]

26. *Snows*, January-February 1967, Martinique Theater, New York
Black-and-white film, silent, 16mm, 24 min.
Filmed by Alphonse Shilling, unedited [see also 23]

27. *Illinois Central Transposed*, March 1969, The Ark, Boston
Color film, silent, 16mm, 5 min.
Filmed by Robert Dacey, rough edit

28. *Up To And Including Her Limits*, June 10, 1976, Studiogalerie, Berlin
Color videotape, sound, 29 min.
Taped by Mike Steiner

29. *HOMERUNMUSE*, first performed November 1977, Brooklyn Museum, New York

Black-and-white videotape, sound, 60 min.
Taped by Ricky Slater

30. *Fresh Blood—A Dream Morphology*, 1983, University of Iowa
Theater Festival, Iowa City
Color videotape, sound, 40 min.
Edited by Carolee Schneemann

31. *Catscan*, first performed 1987, Medicine Show, New York
Color videotape, sound
Taped by Victoria Vesna, unedited

32. *Ask the Goddess*, first performed 1991, Canadian Centre of the
Arts at Owen Sound
Color videotape, sound, unedited

33. *Center for Creative Photography Lecture*, October 1992, Tucson,
Arizona
Color videotape, sound, unedited

34. *Vulva's School*, January 29, 1995, Western Front, Vancouver
Color videotape, sound, edited

35. *Interior Scroll: The Cave*, Summer 1994, Widow Jane Cave, Rose-n-
dale, New York
Color videotape, sound
Edited and produced by Maria Beatty

E) *PERFORMANCE WORKS RECONFIGURED THROUGH MIXED-
MEDIA INSTALLATION*

36. *Up To And Including Her Limits*, first performed December 1973,
Avant-Garde Festival, Grand Central Terminal, New York
Two large scale drawings, 72 x 96" (approximate), harness with
manila rope, two video decks with six monitors, 8mm film projector,
video compilation of various performaces edited by Carolee

Schneemann, 1982; dimensions variable

37. *Interior Scroll*, first performed August 1975, Women Here and Now
Festival, East Hampton, New York
Photograph, box with paper scroll; 50 x 30 x 10" (approximate)
Collection Eileen and Peter Norton

F) *INSTALLATIONS*

38. *Video Rocks*, 1989
Handmade "rocks" (cement, ashes, sawdust, urine, ground glass),
lighting rods, four video decks with eight monitors, and wall-scale
canvas (ashes, cement, paint and sand); dimensions variable

39. *Mortal Coils*, 1994
Four slide projectors, two dissolve units, motorized mirrors, sixteen
motorized ¾" manila ropes, photo blueprint text, lights, booklets,
and flour; dimensions variable

G) *FILMS*
[Note: All films to be shown in video versions only, except for sched-
uled screenings at the Anthology Film Archives; * indicates
Anthology screenings only]

40. *Viet-Flakes*, 1965
Black-and-white toned film, sound collage by James Tenney, 16mm,
11 min.

41. *Fuses* (Part I of Autobiographical Trilogy), 1964-67
Color film, silent, 16mm, 22 min.

42. *Plumb Line* (Part II of Autobiographical Trilogy), 1968-71
Color film, sound, s8 step printed to 16 mm, 18 min.

43.* *Kitch's Last Meal* (Part III of Autobiographical Trilogy), 1973-78
Color film, separate sound, s8 dual projection, variable units from 20
minutes to 2 hours

Biography

Galerie Samuel Lallouz, Montreal. September-October 1996

Elga Wimmer Gallery, New York. May-June 1996

Mount Saint Vincent University Gallery, Halifax, Nova Scotia. September 1995

Kunstraum, Vienna. April-May 1995

Galerie Krinzinger, Vienna. April-May 1995

Fine Arts Center Gallery, University of Rhode Island, Wakefield, Rhode Island. March 1995

Penine Hart Gallery, New York. March 1994

Syracuse University, Syracuse, New York. February 1994

Randolph St. Gallery, Chicago. November 1992

Walter/McBean Gallery, San Francisco Art Institute, San Francisco. 1991

Emily Harvey Gallery, New York. 1990

Emily Harvey Gallery, New York. 1988

Henri Gallery, Washington, DC. 1986

Max Hutchinson Gallery, New York. 1985

Kent State University, Department of Fine Arts, University Gallery, Kent, Ohio. 1984

Maryland Institute-College of Art, Baltimore. 1984

Max Hutchinson Gallery, New York. 1983

Colby-Sawyer College, New London, New Hampshire. 1983

Rutgers University, Douglass College, New Brunswick, New Jersey. 1983

Max Hutchinson Gallery, New York. 1982

Real Art Ways, Hartford, Connecticut. 1981

Washington Project for the Arts, Washington, DC. 1981

Stichting De Appel, Amsterdam, the Netherlands. 1979

SELECTED GROUP EXHIBITIONS

Elga Wimmer Gallery, New York. "Fifth Year Celebration." July-August 1996

Museum of Contemporary Art, Los Angeles. "Hall of Mirrors: Art and Film Since 1945." March-July 1996, traveling exhibition

UCLA Armand Hammer Museum, Los Angeles. "Sexual Politics: Judy Chicago's Dinner Party in Feminist Art History." April-June 1996

Kunsthallen Brandts Klaedefabrik, Odense, Denmark. "The Body as a Membrane." January-March 1996

Galerie Samuel Lallouz, Montreal. "Drawings and Maquettes by Sculptors." January-February 1996

Annika Sundvik Gallery, New York. "Estro Turf." January-February 1996

Whitney Museum of American Art, New York. "Beat Culture and the New America: 1950-1965." November 1995-February 1996, traveling exhibition

Lombard/Freid Fine Arts, New York. "Wheel of Fortune: Artists Interpret the Tarot." December 1995-January 1996

Centre Georges Pompidou, Paris. "Feminin/Masculin: le sexe de l'art." October 1995-January 1996

Museum of Contemporary Art, Tokyo. "Revolution: Art of the Sixties from Warhol to Beuys." September-December 1995

Elga Wimmer Gallery, New York. "Women on the Verge (Fluxus or Not)." September-October 1995

Craig Krull Gallery, Pasadena, California. "Action/Performance and the Photograph." August 1995

Hal Bromm Gallery, New York. "Phallic Symbols: Images in Contemporary Art." May-July 1995

Snug Harbor Cultural Center, Staten Island, New York. "Outside the Frame: Performance and the Object." February-June 1995

Cristinerose Gallery, New York. "Revealing Desire." February-March 1995

Exit Art, New York. "Endurance." March-April 1995

Museum of Modern Art, New York. "Recent Acquisitions: Photography." January-April 1995

University Art Museum, University of California at Berkeley, Matrix Gallery. "In a Different Light." January-April 1995

Natalie Karg/Josh Baer Gallery, New York. "Acconci, Antoni, Burden, Mendieta, Nauman, Schneemann, Wilke." January-April 1995

The Equitable Gallery, New York, organized by the American Federation of Arts, New York. "Neo-Dada: Redefining Art." January-March 1995, traveling exhibition

Centre Georges Pompidou, Paris. "*Hors Limites* 1960-1995." October 1994-January 1995

Kunstverein, Munich. "Oh Boy! It's a Girl!" July-August 1994

Cleveland Center for Contemporary Art, Ohio. "Outside The Frame: Performance and the Object." February-May 1994

Whitney Museum of American Art, New York. "Abject Art." June-September 1993

Turner/Krull Gallery, Los Angeles. "Action/Performance and the Photograph." July-August 1993

Carla Stellweg Gallery, New York. "Living Rites." June 1993

David Zwirner Gallery, New York. "Coming to Power-25 Years of Sexually X-Plicit Art by Women." May-June 1993

Walker Art Center, Minneapolis. "In The Spirit of Fluxus." February-June 1993, traveling exhibition

Exit Art, New York. "1920: The Subtlety of Subversion—The Continuity of Interversion." March-April 1993

Bard College, Annandale-on-Hudson, New York. "Please Observe." March-April 1993

Penine Hart Gallery, New York. "Bodily." February-March 1993

Contemporary Arts Center, Cincinnati, Ohio. "Performing Objects." January-March 1993

The New Museum of Contemporary Art, New York. "FluxAttitudes." September 1992-January 1993

Emily Harvey Gallery, New York. "Music for Eye and Ear." 1992

San Francisco Museum of Modern Art, San Francisco. "The Projected Image 1991." 1991

Pittsburgh Center for the Arts, Pittsburgh. "Iron City Flux" and "Fluxus Deluxe." 1991

Bard College, Annandale-on-Hudson, New York. "The Tao of Contemporary Art." June-September 1990

Venice Biennale, Italy. "The Avant-Garde 1950-1990." June-September 1990

Stadtische Kunsthalle, Dusseldorf. "Concrete Utopia." June 1990

Emily Harvey Gallery, New York. "Christmas Group Exhibit." 1990

Salvatore Ala, New York. "Fluxus Closing In." 1990

Jan Kesner Gallery, Los Angeles. "Pharmacy." 1990

Alternative Museum, New York. "The Theater of the Object, 1958-1972: Reconstructions, Recreations, Reconsiderations." 1989

Emily Harvey Gallery, New York. "Fluxus & Co." 1989

Museum School of Fine Arts, Boston. "New Rituals in Contemporary Art." 1988

The Alternative Museum, New York. "Apollo, Dionysus and Job: Performance Art and the Theatre of the Object." 1988

Everson Museum, Syracuse, New York. "Sacred Spaces." 1987

Artists Space, New York. "Dark Rooms." 1987

Ceres Gallery, New York. "The Political is Personal." 1987

Clocktower, New York. "Letters." 1986

Whitney Museum at Philip Morris, New York. "Modern Machines; Recent Kinetic Sculpture." 1985

Max Hutchinson Gallery, New York. "Recent Work." 1985

Whitney Museum of American Art, New York. "Blam! The Explosion of Pop, Minimalism and Performance 1958-1964." 1984

P.S.1, Long Island City, New York. "Salvaged — The Origins of Assemblage." 1984

Franklin Furnace, New York. "Carnival Knowledge." 1984

Blum Avery Gallery, Bard College, Annandale-on-Hudson, New York. "Art As Social Conscience." 1984

The Clocktower, New York. "Film as Installation." 1983

Rochester Institute of Technology. "Events by Eight Artists." 1983

International Center for Photography, New York. "The Pornographic and Erotic Image – Toward Definition and Implication." 1982

Warsaw Museum of Art; Lodz Museum of Art; National Museum of Wroclaw, Poland. "Labyrinth of Self Consciousness." 1982

Grey Art Gallery and Study Center, New York University, New York. "Judson Dance Theater 1962-1966." 1982

State University of New York, Buffalo. "Performing the Person: Displacements of Life Narrative." 1982

Pratt Manhattan Center Gallery, New York. "Tracking, Tracing, Marking." 1982

Tibor de Nagy Gallery, New York. "Broken Surface." 1981

Contemporary Art Center, New Orleans. "A Decade of Women's Performance Art." 1980

Palazzo Reale, Milan, Italy. "Camere Incantate/Espansione dell'Immagine."
　　1980
Cooper-Hewitt Museum, New York. "The Museum of Drawers." 1978
Los Angeles Institute of Contemporary Art, Los Angeles. "Artwords and
　　Bookworks." 1978
Franklin Furnace, New York. "Artists' Books." 1978
Centre Georges Pompidou, Paris. "La Boutique Aberrante." 1977

Selected Bibliography

*MAGAZINE, JOURNAL AND NEWSPAPER ARTICLES, SCHOLARLY
PAPERS*

Allara, Pamela. "'Mater' of Fact: Alice Neel's Pregnant Nudes." *American
　　Art* (Spring 1994): 17.
Alloway, Lawrence. "Carolee Schneemann: The Body as Object and
　　Instrument." *Art in America* (March 1980): 19-21.
Anderson, Jack. "How the Judson Theater Changed American Dance." *New
　　York Times* (January 31, 1982)
----------. "What Happens at a Happening?" *Dance Magazine* (1967)
Anderson-Spivy, Alexandra. "The Return of Aphrodite." *The Argonaut
　　Journal*, no.2 (1993): 21-22.
Antin, David. Review. *Art News* (1967)
Baker, Kenneth. "Sliding Art out of Shadows." *San Francisco Chronicle*
　　(March 7, 1991)
Ballerini, Julia. Review. *Art in America* (April 1983)
Biancolli, Amy. "Portrait of the Artist as a Angry Woman." *Albany Times
　　Union* (March 1993)
Birringer, Johannes. "Imprints and Revisions: Carolee Schneemann's Visual
　　Archaeology." *Performance Art Journal* (June 1993): 31-46.
Bociurkiw, Marusya. *Parachute* 79 (Summer 1995): 53-54.
Bonetti, David. "Sliding towards New Narrative Forms." *San Francisco
　　Examiner* (March 15, 1991): C-2.
Brignone, Patricia. "Hors Limite - L'art et la Vie 1952-1994." *Art Presse*
　　(January 1995): 18-19.
Brownmiller, Susan. "Women in the Year 2000." *Ms.* (March 1976)

Burnside, Madeline. "Carolee Schneemann." *Arts Magazine*
　　(February 1980)
Cameron, Daniel J. "Object vs. Persona: Early Work of Carolee
　　Schneemann." *Arts Magazine* (May 1983): 122-125.
Canaday, John. "Art: Unforgivable Assemblages." *New York Times*
　　(May 14, 1963)
Castle, Frederick Ted, and Lisa McClure. *Review* (June 1996): 13-14, 27.
Castle, Ted. "The Woman who Uses her Body for Art." *Artforum* (November
　　1980): 64-70.
Chin, Daryl. "Those Little White Lies." *M/E/A/N/I/N/G Journal*, no. 13
　　(1993): 26-27.
Cohn, Terri. "A Grace Silence: From Hitler to Helms." *Artweek* (November
　　7, 1991): 8.
Cole, Robert. "Carolee Schneemann: More than Meat Joy." *Performance
　　Art*, (March 1979): 8-15.
Costantinides, Kathy. "Carolee Schneemann: Invoking Politics." *Michigan
　　Quarterly Review* (Winter 1991): 127-145.
Cottingham, Laura. "How Many 'Bad' Feminists Does it Take to Change a
　　Lightbulb?" *Lightbulb* (Summer 1994):11,21.
Crowder, Joan. "The End." *Santa Barbara News-Press* (April 12, 1996):
　　21.
Drucker, Joanna. "Visual Pleasure: A Feminist Perspective." *M/E/A/N/I/N/G
　　Journal* (May 1992): 9.
Export, Valie. "Aspects of Feminist Actionism." *New German Critique*
　　(Spring-Summer 1989): 69-92.
Frank, Peter. "Sculpture at the 1990 Venice Biennale." *Sculpture*
　　(September-October 1990): 37-39.
Frederick, Charles. "Fresh Blood: A Dream Morphology." *LIVE: Magazine
　　of Performance* 6/7 (1982): 58-59.
Frueh, Joanna. "Fuck Theory." Paper presented at meeting of Society for
　　Photographic Education, Washington, DC, 1992.
Fuchs, Elinor. "Staging the Obscene Body." *Tulane Drama Review* (Spring
　　1989): 34.
Gibbs, Michael. "Everything in the Art World Exists in Order to End Up as a
　　Book." *Art Communication* (July 1977)

Glassner, V. "Interviews with Three Filmmakers." *Time Out* (March 1972): 47.

Glueck, Grace. "Exploring Six Years of Pop and Minimalism." *New York Times* (September 28, 1984)

----------. Review. *New York Times* (February 24, 1984)

----------. Review. *New York Times* (September 10, 1982)

----------. "Intermedia '69." *New York Times* (March 6, 1969)

----------."Every Painting is a Failure." *New York Times* (October 8, 1967)

----------."Multimedia Bombards the Senses." *New York Times* (September 16, 1967)

Hackman, William. "Yes, but What is it?" *The J. Paul Getty Trust Bulletin* 9, no.3 (Winter 1996): 2-3.

Haden-Guest, Anthony. "Live Art." *Vanity Fair* (April 1992): 212.

Haller, Robert A. Review. *Field of Vision* (Spring 1985): 27.

----------."Rolling in the Maelstrom." *Idiolects* (Spring 1984): 50-55.

----------. "Amy Greenfield and Carolee Schneemann: An Introduction." *Field of Vision* (Fall 1978)

Hayward, Carl. "Interview—Carolee Schneemann." *Art Papers* (January-February 1993): 9-16.

Hess, Elizabeth. "Basic Instincts." *The Village Voice* (June 1, 1993)

Howell, John. "Judson, the Attitude." *Alive* (July-August 1982): 32-33.

Hughes, Allen. Review. *New York Times* (March 17, 1964)

Hughes, Robert, and Eleanore Lester. "The Final Decline and Total Collapse of the American Avant-Garde." *Esquire,* (May 1969): 142.

Hunter, Dianne. "Theaters of the Female Body." *Theatre Topics* (March 1993)

Hutchinson, Peter. "Moving Paintings." *Art in America* (1967)

Jackson, George. "Naked in its Native Beauty." *Dance Magazine* (April 1964): 32-37.

James, David. "Carolee Schneemann." *Cinematograph: A Journal of Film and Media Art* 3 (1988): 36-38.

Johnston, Jill. "The New American Modern Dance." *Salmagundi* (Spring/Summer 1976): 149-174.

----------. "Dance: Meat Joy." *The Village Voice* (November 26, 1964)

Jones, Amelia. "Presence and Calculated Absence." *Tema Celeste* (Winter 1993)

----------. "The Return of the Feminist Body." *M/E/A/N/I/N/G Journal* (November 1993): 3-6.

Joselit, David. "Projected Identities." *Art in America* (November 1991)

Kandel, Susan. "The Binge-Purge Syndrome." *Art Issues* (May-June 1993): 19-22.

Katz, Vincent. Review. *Art in America* (November 1994): 127-28.

Klinger, Linda. "Where's the Artist? Feminist Practice and Poststructural Theories of Authorship." *Art Journal* (Summer 1991): 39-41.

Kozloff, Max. "Pygmalion Reversed." *Artforum* (November 1975): 30-37.

Kultermann, Udo. "l'Universe de Carolee Schneemann." *Vie des Arts* (June 1987): 117.

Larson, Kay. "Women's Work (or is it Art?) Is Never Done." *New York Times* (January 7, 1996): 35.

Lester, Eleanore. "Intermedia: Tune in, Turn on, and Walk Out." *New York Times Magazine* (May 12, 1968): sect. 6, 22-32.

----------. "Mind Field." *New York Magazine* (February 21, 1994): 55-56.

Levi Strauss, David. "The Final Stages of the End! Enter the Great Tribulation!" *Camera Work* (1994): 22-23.

----------. "Therapeutic Art and Images in Context." *Art Issues* (September/October 1994): 29-33.

Lippard, Lucy R. "Quite Contrary: Body, Nature, Ritual in Women's Art." *Chrysalis* 2 (1977): 36, 37.

----------. "Women's Body in Art." *Art in America* (June 1976)

Lovelace, Carey. "The Gender and Case of Carolee Schneemann." *Millennium Film Journal* (Fall/Winter 1986-1987): 162-168.

Mackey, Heather. "Body Language." *San Francisco Bay Guardian* (February 20, 1991): cover, 19-20.

MacDonald, Scott. "Carolee Schneemann's ABC: The Men Cooperate." *AfterImage* (April 1985): 12-15.

----------. "Plumb Line." *Millennium Film Journal* 10-11 (Fall/Winter 1981-1982): 111-114.

----------. "Carolee Schneemann's Autobiographical Trilogy." *Film Quarterly* (Fall 1980): 27-32.

----------. "An Interview with Carolee Schneemann." *AfterImage* (March 1980): 10-11.

Martin, Henry. Review. *Flash Art* (1981)

Martin, Maureen. "Challenging Distortions of the Dominant Male Imagination." *VOX: Magazine of Contemporary Art and Culture* (Spring 1992): 12-14.

McDonagh, Don. "Carolee Schneemann." *Artforum* (May 1976): 73-75.

----------. "Un-Expected Assemblage!" *Dance Magazine* (June 1965): 42-44.

McEvilley, Thomas. Review. *Artforum* (April 1985): 91.

----------. "Art in the Dark." *Artforum* (Summer 1983): 62-64.

Mifflin, Margot. "The Sleep of Reason: Artists and their Dreams." *High Performance* (Spring 1987): 50-51.

Migdoll, Herbert. Review. *Horizon* (Summer 1967): 101.

Miller, Lisa. "Naked Aggression." *Self* (November 1993): 144-147, 174.

Montano, Linda. "Interview with Carolee Schneemann." *The Flue* (1982)

Morgan, Robert. "Reconstructing with Shards." *American Ceramics* (Winter 1983): 38-39.

Munsterburg, Hugo. "The Critic at Seventy-Five." *Art Journal* (Spring 1994): 65.

Nemser, Cindy. "Four Artists of Sensuality." *Arts Magazine* (March 1975): 73-75.

Nichols, Mary Perot. "A Scandal Ripens in my Fair City." *The Village Voice* (November 26, 1964): 1.

O'Dell, Kathy. "Fluxus Feminus." From symposium "In the Spirit of Fluxus," Walker Art Center, Minneapolis, 1993.

Orloff, Kossia. "Women in Performance Art: the Alternate Persona." *Heresies* 17, no.1 (1984): 36-37.

----------. "Black Mythology in White Performance." *LIVE* (September 1982)

Peterson, William. "Interview with Carolee Schneemann." *ACT: Journal of Performance Art* (1989)

Picard, Lil. "Art." *East Village Other* (January 24, 1969)

Preston, Janet. "What's Wrong with Janine Antoni?" *Coagula* 15 (November 1994)

Rahmani, Avira. "A Conversation on Censorship with Carolee Schneemann." *M/E/A/N/I/N/G Journal* (November 1989): 3-7.

Reveaux, Tony. "Mopping Up: Carolee Schneemann at SFAI." *Artweek* (November 7, 1991)

Rich, B. Ruby. "Sex and Cinema." *New Art Examiner* (Spring 1979)

Rickels, Laurence A. "Act Out Turn On." *Artforum* (April 1994): 70-73, 127.

Robinson, Lou. "Subvert Story." *American Book Review* (February-March 1991): 9.

Sanborn, Keith. "Modern, All too Modern." *Cinematograph: A Journal of Film and Media Criticism*, vol. 3 (1988): 108.

Sanford, Christy Sheffield. "Interview with Carolee Schneemann." *Red Bass: Journal of Politics and Art* (1989): 16-23.

Schaffner, Ingrid. Review. *Artforum* (September 1994): 108-109.

Silverthorne, Jeanne. Review. *Artforum* (December 1983): 73.

----------. Review. *Print Collector's Newsletter* (November-December 1983)

Sklar, Robert. "Working Against Existing Taboos." *Soho Weekly News* (May 31, 1979): 29-30.

Smith, Barbara. "The Body in Politics." *Art Week* (October 1990)

Smith, Howard. "Scenes: The Abominable Schneemann." *The Village Voice* (December 28, 1967)

Smith, Michael. "Theatre: Snows." *The Village Voice* (January 26, 1967)

----------. "Theatre: Meat Joy." *The Village Voice* (November 26, 1964)

Smith, Roberta. "Venice: Men Look, Women Display." *New York Times* (July 9, 1995)

Spector, Buzz. "A Profusion of Substance." *Artforum* (October 1989): 120-128.

Spector, Nancy. "Double Fear." *Parkett* (December 1989): 130.

Springer, Jane. "Developing Feminist Resources: Schneemann and Rosler." *Fuse* (January 1980): 113-116.

Steffen, Barbara. "Gender Culture." *Kultur* (March/April 1994): 15.

Stevens, Mark. "Fluxus Redux." *Vanity Fair* (July 1993): 98-99.

Straayer, Chris. "The She-Man: Postmodern Bisexed Performance." *Screen* (Fall 1990): 268.

Tillman, Lynn. "Words without Pictures." *Bomb* 4 (1982): 52.

Wooster, Ann-Sargent. "Up To And Including Her Limits." *Artforum* (May 1976)

Youngblood, Gene. "Underground Cinema." *Los Angeles Free Press* (July 19, 1968)

BOOKS, EXHIBITION CATALOGUES

Alternative Museum. *Disinformation: The Manufacture of Consent*. New York: Alternative Museum,1985.

Anderson, Patricia. *All of Us*. New York: Bantam Doubleday Dell, 1996.

Armstrong, Elizabeth and Joan Rothfuss, eds. *In the Spirit of Fluxus*. Minneapolis: Walker Art Center, 1993.

Atkins, Robert. *Art Speak: A Guide to Contemporary Ideas, Movements and Buzzwords*. New York: Abbeville Press, 1990.

Auwe, Walter, and Deborah Jowitt. *Time and the Dancing Image*. Berkeley: University of California Press, 1980.

Banes, Sally. *Terpsichore in Sneakers*. Middletown: Wesleyan University Press, 1977.

Benedikt, Michael. *Theater Experiment*. New York: Doubleday, 1967.

Berger, Maurice. *How Art Becomes History*. New York: Harper Collins Icon Editions, 1992.

-----------. *Labyrinths: Robert Morris, Minimalism and the 1960s*. New York: Harper & Row, 1989.

-----------. "Carolee Schneemann: Snows." In *Representing Vietnam*. New York: Hunter College Art Gallery, 1988.

Berke, Joseph, ed. *Counter Culture*. London: Peter Owen, Ltd., 1970.

Bernadac, Marie-Laure, Robert Storr, et al. *Feminin/Masculin: Le Sexe de l'Art*. Paris: Centre Georges Pompidou, 1995.

Bloch and Celender. *Mortal Remains*, New York/Minneapolis: O.K. Harris Gallery/Intermedia Arts Minnesota, 1996.

Bongard, Nicola, Hedwig Saxenhuber, and Astrid Wege. *Oh Boy, It's a Girl: Feminismen in der Kunst*. Munich: Kunstverein, 1994.

Brentano, Robin. *Outside the Frame: A Survey History of Performance Art in the USA Since 1950*. Cleveland: Center for Contemporary Art, 1994.

Broude, Mary D., and Norma Garrard, eds. *The Power of Feminist Art*. New York: Harry Abrams Inc., 1994.

Brougher, Kerry and Russell Ferguson. *Hall of Mirrors: Art and Film Since 1945*. Los Angeles: Museum of Contemporary Art, 1996.

Caws, Mary Ann. *Joseph Cornell: Selected Diaries, Letters and Files*. New York: Thames and Hudson, 1993.

Celant, Germano. *Architecture by Artists*. Venice: La Biennale di Venezia, 1976.

Chicago, Judy, and Miriam Schapiro, *Anonymous Was a Woman*. Valencia: Feminist Arts Program, California Institute of the Arts, 1974.

Conz, Francesco, Ken Friedman, et al. *Fluxus!* Brisbane: Institute of Modern Art, 1990.

Crow, Thomas. *The Rise of the Sixties: American and European Art in the Era of Dissent*. New York: Harry Abrams Inc., 1996.

Davis, Douglas. *Art and the Future*. New York: Praeger, 1973.

Decker, Elisa. *The Male Nude: Women Regard Men*. New York: Hudson Center Galleries, 1986.

Dreyfuss, Charles. "Carolee Schneemann." In *Happenings and Fluxus*. Paris: Galerie 1900-2000, 1989.

Dubin, Steve. *Arresting Images*. London: Routledge Press, 1992.

Dwoskin, Stephan. *Film Is*. Woodstock, New York: The Overlook Press, 1975.

Elder, Bruce R. *The Body in Film*. Toronto: Art Gallery of Ontario, 1989.

Ewing, Bill. *The Body: Photographs of the Human Form*. New York: Thames and Hudson, 1994.

Export, Valie, ed. *Kunst mit Eigen-Sinn: Texte und Dokumentation*. Vienna: Museum Moderner Kunst, 1985.

Feuerstein, Georg. *Sacred Sexuality*. New York: Pedigree Books, 1992.

Freuh, Joanna, Cassandra Langer, and Arlene Raven, eds. *New Feminist Criticism*. New York: Harper Collins, 1994.

Gadon, Elinor. *The Once and Future Goddess*. New York: Harper & Row, 1989.

Gibbs, Michael. "Introduction to Erotic Films by Women." In *Deciphering America*. Amsterdam: Kontexts, 1978.

Goldberg, Roselee. *Performance Art: From Futurism to the Present*. London: Thames & Hudson, 1978.

Greenfield, Amy, ed. *Film Dance*. New York: Public Theater, 1984.

Gruen, John. *The New Bohemia*. New York: Grosset and Dunlap, 1967.

Hansen, Al. *A Primer of Happenings and Time/Space Art*. New York: Something Else Press, 1966.

Hapgood, Susan. *Neo-Dada: Redefining Art 1958-1962*. New York: American Federation of Arts, 1994.

Haskell, Barbara. *Blam! The Explosion of Pop, Minimalism and Performance 1958-1964*. New York: The Whitney Museum of American Art, 1984.

Henri, Adrian. *Total Art: Environments, Happenings, Performance*. London: Thames and Hudson, 1974.

Hoffmann, Katherine. *Explorations: The Visual Arts Since 1945*. New York: Harper Collins, 1991.

Howell, John, ed. *Breakthroughs: Avant-Garde Artists in Europe and America 1950-1990*. Columbus: Wexner Center for the Arts, 1991.

Institute for Art & Urban Resources. *Salvaged: Altered Everyday Objects*. New York: Institute for Art & Urban Resources, 1984.

James, David. *Films Against the War in Vietnam*. New York: Whitney Museum of American Art, 1990.

----------. *Allegories of Cinema: American Film in the Sixties*. Princeton: Princeton University Press, 1989.

Jones, Leslie C. "Transgressive Femininity." In *Abject Art: Repulsion and Desire in American Art*. New York: The Whitney Museum of American Art, 1993.

Jowitt, Deborah. *Time and the Dancing Image*. Berkeley: University of California Press, 1988.

Juno, Andrea, and V. Vale, eds. *Re/Search 13: Angry Women*. San Francisco: ReSearch Publications, 1991: 66-77.

Kaprow, Allan. *Allan Kaprow: Essays on the Blurring of Art and Life*, edited by Jeff Kelley. London: University of California Press, 1993.

Katz, Robert. *Naked by the Window*. New York: Atlantic Monthly Press, 1990.

Kent, Sarah, and J. Morreau, eds. *Women's Images of Men*. London: Pandora Press, 1984 [reprinted 1990].

Kohler, Michael, and Gisela Barche. *Das Aktfoto*, Munich: Münchner Stadtmuseum, 1985.

Kranz, Stewart. *Science and Technology in the Arts*. New York: Van Nostrand Reinhold Co., 1974.

Kultermann, Udo. *Contemporary Masterworks*. London: St. James Press, 1990.

----------. *Art-Events and Happenings*. London: Mathews Miller Dunbar, 1971.

----------. *Art and Life*. New York: Praeger, 1970.

Labelle-Rojoux, Arnaud. *L'Acte pour l'Art*. Paris: Editeurs Evident, 1988.

Lebel, Jean-Jacques. *Happenings, Interventions et Actions Diverses 1962-1982*. Paris: Cahiers Locques, 1982.

Levy, Mark. *Technicians of Ecstasy: Shamanism and the Modern Artist*, Bramble Books, 1993.

Lippard, Lucy. *The Pink Glass Swan: Selected Feminist Essays on Art*. New York: The New Press, 1995.

----------. *A Different War — Vietnam in Art*. Bellingham, Washington: Whatcom Museum of History and Art, 1990.

----------. *Overlay: Contemporary Art and the Art of Prehistory*. New York: Pantheon Books, 1984.

Lucie-Smith, Edward. *Race, Sex and Gender in Contemporary Art*. London: Abrams, 1984.

----------. *Art Now*. Milan: Mondadori Editore, 1977 [reprinted 1989].

MacDonald, Scott. *Avant-Garde Film: Motion Studies*. London: Cambridge University Press, 1993.

----------. *A Critical Cinema*. Berkeley: University of California Press, 1988.

McDonagh, Don. *The Complete Guide to Modern Dance*. New York: Doubleday, 1976.

Moore, Sylvia, and C. Navaretta. *Artists and their Cats*. New York: Mid-March Arts Press, 1990.

Morgan, Robert C. *Essays on Conceptual Art*. Cambridge: Cambridge University Press, 1996.

----------. *Conceptual Art: An American Perspective*. New York: McFarland & Co., 1994.

----------. *After the Deluge: Essays on Art in the Nineties*. New York: Red Bass Publications, 1993.

Murphy, Jay. *Imaging Her Erotics: The Body Politics of Carolee Schneemann*. Cambridge: MIT Press, 1997.

Myers, George Jr. *Alphabets Sublime: Contemporary Artists on Collage and Visual Literature*. Washington: Paycock Press, 1986.

Nahas, Dominque. "Venus Vectors." In *Sacred Spaces*. Syracuse: Everson Museum of Art, 1987.

Nead, Lynda. *The Female Body*. London: Routledge Press, 1992.

Neiman, Catrina. "Woman Pioneers of American Experimental Film." In *Feministische Streifzuge durch's Punkte-Universum*. Vienna: Film Werkstatt, 1993.

-----------. *Women in Film*. Dortmund: 1992.

Oldenburg, Claes. *Store Days*. New York: Something Else Press, 1966.

Perron, Wendy, and Daniel J. Cameron, eds. *Judson Dance Theater: 1962-1966*. Bennington, Vermont: Bennington College Judson Project, 1981.

Phillips, Lisa. *Beat Culture and the New America: 1950-1965*. New York: Whitney Museum of American Art, 1995.

Pultz, John. *Photography and the Body*. London: Calmann and King, 1995.

Rathus, Nevid. *Human Sexuality in a World of Diversity*. Boston: Allyn & Bacon, 1993 [reprinted 1995].

Rich, B. Ruby. "The Independent Film." In *Films by Women/Chicago*. Chicago: Film Center of the School of the Art Institute of Chicago, 1974.

Riley, Robert. T*he Making of a Modern Museum*. San Francisco: San Francisco Museum of Modern Art, 1994.

Rinder, Larry, ed. *In a Different Light*. San Francisco: City Lights Books, 1995.

Robertson, Richard, and Alain-Martin Clive. *Performance au/in Canada 1970-1990*. Toronto: Editions Interwenken, 1991.

Rosen, Randy, ed. *Making their Mark: Women Artists Move into the Mainstream*. New York: Abbeville Press, 1989.

Roth, Moira, ed. *The Amazing Decade: Women and Performance Art 1970-1980*. Los Angeles: Astro Artz, 1983.

Rothenberg, Jerome. *Technicians of the Sacred*. New York: Doubleday & Co., 1968.

Sanford, Mariellen R. *Happenings and Other Acts*. New York: Routledge, 1995.

Sayre, Henry M. *The Object of Performance: the American Avant-Garde Since 1970*. Chicago: University of Illinois Press, 1989.

Schneider, Rebecca, and Paul Kegan. *The Explicit Body*. New York: Routledge, 1996.

The Sculpture Center. *Sound/Art*. New York: The Sculpture Center, 1983.

Sitney, P. Adams. "Interview with Stan Brakhage." In *Film Culture Reader*. New York: Praeger, 1983.

Solomon, Deborah. *Utopia Parkway: The Life of Joseph Cornell*. New York: Farrar Straus, 1994.

Sontag, Susan. *Against Interpretation*. New York: Farrar, Straus and Giroux, 1966.

Stiles, Kristine. "Between Water and Stone." In *In the Sprit of Fluxus*. Minneapolis: Walker Art Center, 1993.

-----------, and Peter Selz, eds. *Documents of Contemporary Art*. University of California Press, 1994.

Straayer, Chris. "The Seduction of Boundaries." In *Dirty Looks: Women, Pornography, Power*. London: British Film Institute, 1993.

Sukenick, Ron. *Down and In: Life in the Underground*. New York: Beech Tree Books, William Morrow Co., Inc., 1986.

Szeemann, Harald, and Hans Sohm. *Happenings and Fluxus*. Cologne: Koelnischer Kunstverein, 1970.

Taylor, Brandon. *Avant-Garde and After: Re-Thinking Art Now*. New York: Harry Abrams Inc., 1995.

Vogel, Amos. *Film as a Subversive Art*. New York: Random House, 1974.

Weintraub, Linda. *The Rebounding Surface: A Study of Reflections*. Anandale-on-Hudson: Bard College, Avery Center for the Arts, 1982.

Youngblood, Gene. *Expanded Cinema*. New York: Dutton, 1970.

WRITING, PUBLICATIONS BY THE ARTIST

ABC-We Print Anything-In the Cards. Beuningen, Holland: Brummense Uitgeverij Van Luxe Werkjes, 1977.

"Ages of the Avant-Garde." *Performing Arts Journal* (January 1994): 18-21.

"Americana I Ching Apple Pie." *High Performance* (Winter 1982): 74.

"Autobiographical Trilogy." *Sheldon Film Theater* (1981): 80-85.

"Cat Scan (New Nightmares/Old History)." *Caprice Magazine* (August 1988): 35-43.

"...Cat Torture in the Liquid Gate." *International Experimental Film Congress* (May-June 1989): 38, 46-47.

Cézanne, She was a Great Painter. New York: Trespass Press, 1974 [reprinted 1976].

"Christmas Tree in Uteri." *Whitewalls: A Journal of Language and Art* (Fall/Winter 1994): 90-91.

"Cycladic Imprints." *Tema Celeste* (Fall 1992)

"Das A and O-Hidden and Found in an Attic." In *Top Ten Review*. Bremen: H&H Schierbok Edition, 1986.

"Death Has No Fat" and "Infinity Kisses." In *Hommage a Joseph Beuys*, edited by Klaus Staeck. Kassel: 1986.

"Dirty Pictures." *High Performance.* (Summer 1981): 72.

Early and Recent Work. Kingston, New York: Documentext, 1983.

"Emergency Sauce Scenarios for Unexpected Friends and Lovers." In *Food Sex Art: The Starving Artists' Cookbook*. New York: Eidia Books, 1991.

"...Enter Vulva." *October: Feminist Art and Critical Practice* (Winter 1995): 40-41.

"Excerpts from More than Meat Joy." *High Performance* (1979): 5-16.

"Fresh Blood-A Dream Morphology – The Blood Link." *Leonardo Magazine* (Winter 1994): 23-28.

"Fresh Blood-A Dream Morphology." *Dreamworks Journal* (Fall 1981): 67-75.

"Fresh Blood-A Dream Morphology." *New Wilderness Letter* (September 1981): 42-56.

"From a Letter." *Idiolects* (Summer 1981): 18.

"From Fresh Blood-A Dream Morphology." *Idiolects* (Winter 1980-81): 27-30.

"Ice Music." In *Fluxus*, edited by Ken Friedman. Chicago: 1987.

"IN SEE WORK IN FIND PUT." *M/E/A/N/I/N/G Journal* (Fall 1991): 18.

"Integrating Sculpture, Space and Sound." *Musicworks: The Journal of Sound Exploration* (Fall 1993): 6-13.

"Kitch's Last Meal." *Cinemanews* (1981): 55-58.

More than Meat Joy: Complete Performance Works and Selected Writings. Kingston, New York: Documentext, 1979.

"The More I Give the More You Steal..." In *Mother Journeys: Feminists Write about Mothering*. Minnesota: Spinsters Ink, 1994.

"Mother Lexicon." *Flux Scan: A Collection of Music and Sound Events*. Den Bosch Holland: Slowscan Editions, 1993.

The Music of James Tenney. Peter Garland, ed. Santa Fe: Soundings Press, 1984.

"Notes." *Performing Arts Journal* (Fall 1977): 21-22.

"Notes from the Underground: A Female Pornographer in Moscow." *The Independent* (Winter 1992): 23-35.

"The Obscene Body/ Politic." *College Art Journal* (Winter 1991): 28-35.

"On Walter Gutman." In "Letters." *Field of Vision* (1985): 31.

Parts of a Body House. Devon, United Kingdom: Beau Geste Press, 1972.

"Parts of a Body House." In *Fantastic Architecture*, edited by Dick Higgins and Wolf Vostell. New York: Something Else Press, 1969.

"Rain Stops after Seven Days." *Unmuzzled Ox*, vol. IV, no. 1 (1976)

"Re: Art in the Dark." In "Letters." *Artforum* (August 1983): 2.

"Selected Text and Drawings from the Performance Work *Dirty Pictures*." *Heresies* (1989): 23, 54-55.

"Seven Recipes." In *Cookpot*, edited by Barbara Moore. New York: Reflux Editions, 1985.

"Shadow Capture." In *Seeing in the Dark*. London: Serpentstail, 1990.

"Snows." *I-KON* (March 27, 1968): 24-29.

"Snows." In *Notations*, edited by John Cage and Alison Knowles. New York: Something Else Press, 1967.

"Unexpectedly Research." *The Argonaut Journal* (1993): 22-25.

"Unexpectedly Research." *Lusitania* (Fall 1992): 143-145.

"Venus Vectors." *Leonardo: Journal of the Arts, Science and Technology* (Fall 1992)

Video Burn. San Francisco: San Francisco Art Institute, 1992.